Color Harmonies

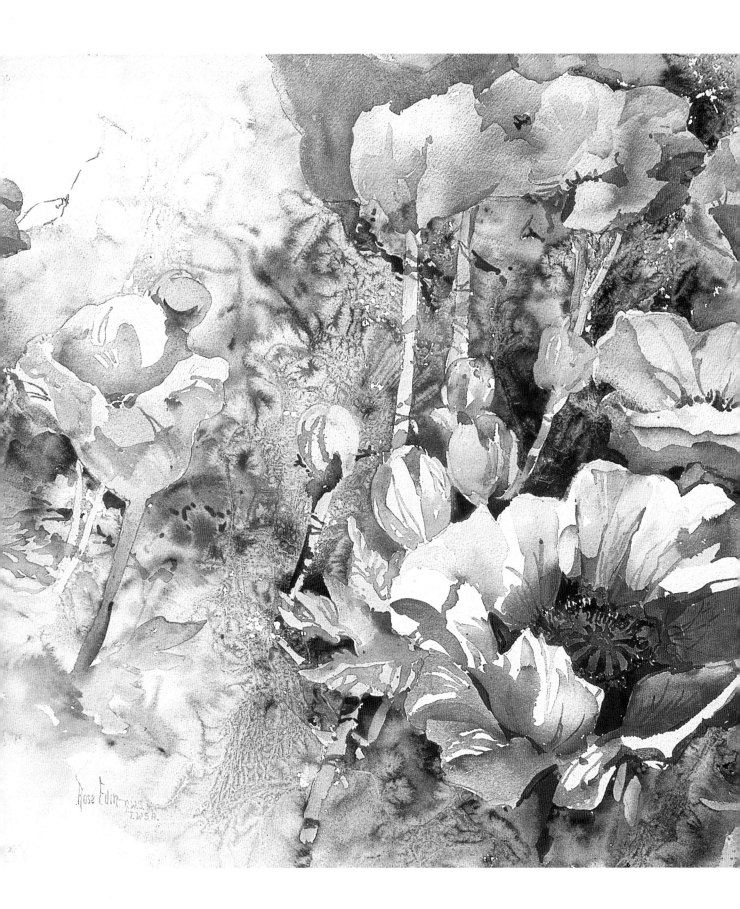

Color Harmonies
paint watercolors filled with light

Rose Edin and Dee Jepsen

NORTH LIGHT BOOKS
CINCINNATI, OHIO
www.artistsnetwork.com

fw
F+W PUBLICATIONS, INC.

Other fine North Light Books are available from your local bookstore or art supply store. Visit us at our website www.fwmedia.com.

14 13 12 11 10 5 4 3 2 1

DISTRIBUTED IN CANADA BY FRASER DIRECT
100 Armstrong Avenue
Georgetown, ON, Canada L7G 5S4
Tel: (905) 877-4411

DISTRIBUTED IN THE U.K. AND EUROPE BY DAVID & CHARLES
Brunel House, Newton Abbot, Devon, TQ12 4PU, England
Tel: (+44) 1626 323200, Fax: (+44) 1626 323319
Email: postmaster@davidandcharles.co.uk

DISTRIBUTED IN AUSTRALIA BY CAPRICORN LINK
P.O. Box 704, S. Windsor NSW, 2756 Australia
Tel: (02) 4577-3555

Library of Congress Cataloging in Publication Data is available from the publisher upon request.

Designed by Guy Kelly
Production coordinated by Mark Griffin
All art created by Rose Edin
Art on cover:
The Secret Garden, 30" × 22" (76cm × 56cm)
Art on page 2:
Poppies, 22" × 30" (56cm × 76cm)

metric conversion chart

To convert	to	multiply by
Inches	Centimeters	2.54
Centimeters	Inches	0.4
Feet	Centimeters	30.5
Centimeters	Feet	0.03
Yards	Meters	0.9
Meters	Yards	1.1

acknowledgments from Rose

Several very special people have had a great influence in my development as an artist, and I would like to acknowledge them here:

Robert E. Wood was one of this country's great watercolorists. His teaching of underpainting and layering color against bright accents were perhaps my greatest inspiration. He was also a master designer and taught me the importance of cohesive design in every painting.

Ed Whitney helped me to establish a personal philosophy of art. Through him, I came to believe we are shape-makers.

Warner Sallman, a world famous painter of religious figures, was my art mentor at North Park University. He was a great encouragement in regard to accuracy in figure drawing.

At times it is a humbling experience to know you can paint and teach, but have a hard time putting it together in writing. Dee Jepsen came along at just the right time to co-author this book. With her experience in writing, art and organization, she has enabled me to get across important art concepts. So thank you, Dee, for a terrific job!

dedication

This book is dedicated to my husband, Stan, my daughter Kathy and my son, Jonathan, who encouraged, typed and critiqued the initial drafts that eventually became this book.

Stan is a computer guru, in addition to being a photographer. The best thing is that he has become a gourmet chef these last few months while I have been working on this book.

Accolades go to my fellow artists and students I have had the pleasure to meet all over the world. They have encouraged and inspired me to stretch my abilities. It is through teaching that I have created many of the techniques shared in this book.

about Rose Edin

From the time she received her first set of paints as an eight-year-old, art has been a passion for Rose. Her high school offered no art classes, so she applied for and won a scholarship to the Art Instruction Schools of Minneapolis, which offered correspondence courses in commercial art.

Teaching junior high school art in central Minnesota for eleven years prepared Rose for the many work-shops she now offers to students from both the United States and aboard. She laughingly says, "If a you can teach junior high students, you can teach anyone!"

During her years as a teacher, she began to enter local and statewide art competitions and received many awards. She is a signature member of the National Watercolor Society and the Transparent Watercolor Society of America, where she holds a master's status.

Rose and her husband, Stan, lead painting and pho-tography groups around the globe to both familiar and remote places, where Rose gleans ideas and inspira-tion for her watercolor paintings.

about Dee Jepsen

Dee was born and raised in the Midwest, but moved to Washington, D.C. when her husband was elected to the U.S. Senate in 1978. In 1981, Dee was appointed to serve on the President's Task Force for Private Sector Initiatives to encourage volunteerism. In 1982 and 1983 she was appointed to serve at the White House as a Special Assistant to the President for Public Liaison to women's organizations.

Following her government service in Washington, Dee wrote an award-winning book *Women: Beyond Equal Rights*. Since that time she has authored three other books, and has written articles for inclusion in numer-ous other books and publications.

Dee has studied and painted in oil and acrylic for 35 years, including summer study at the ArtStudy pro-gram in Giverny, France. She paints many animal por-traits for clients, and donates paintings for auction at charitable events. Only recently she has begun painting in watercolor under the instruction of Rose Edin.

contents

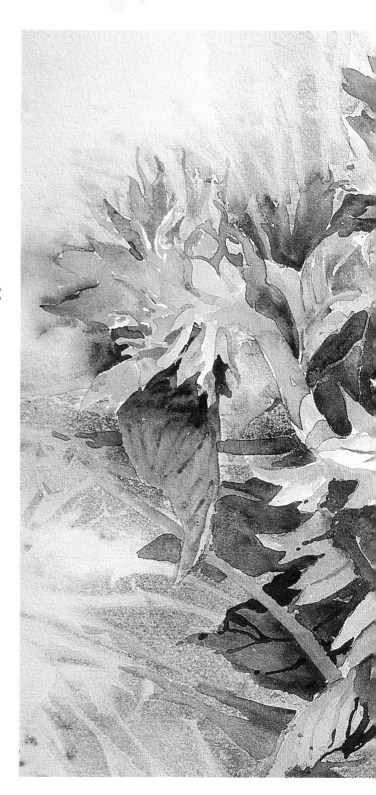

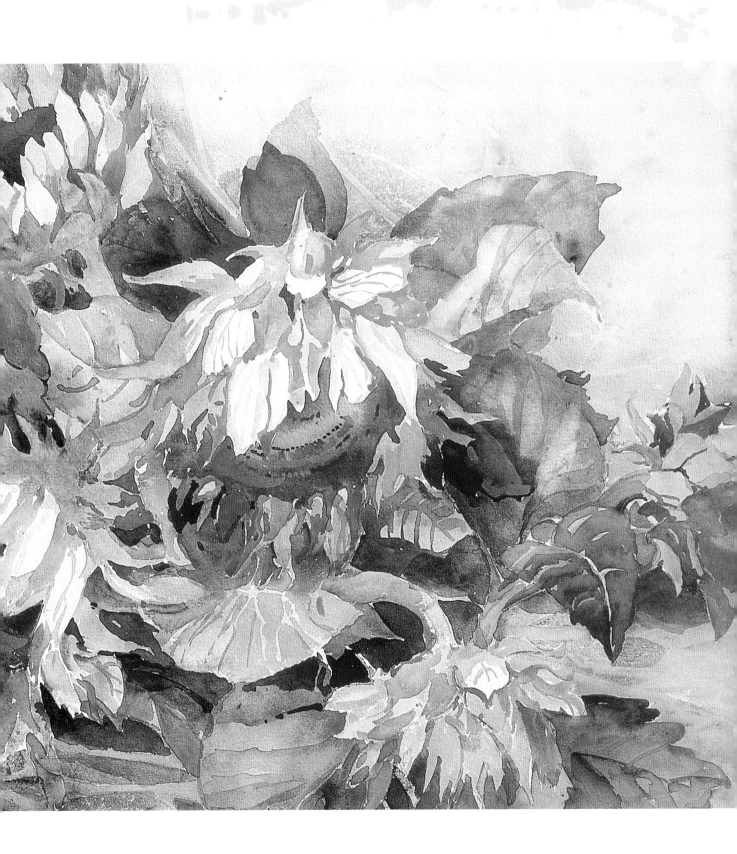

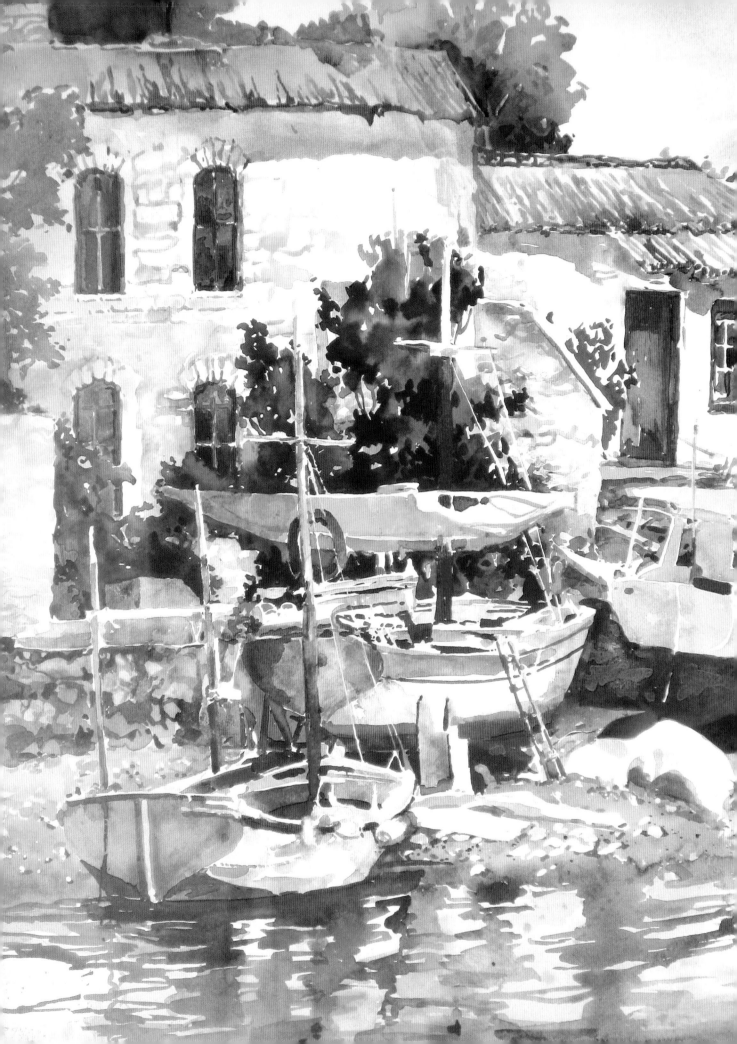

preface

What a joy it has been for me to work on this book with Rose. She can certainly be counted among the best watercolorists in the country. In addition to being a great watercolorist, she is a wonderful woman and has become a very good friend. I have personally learned immensely by writing about and studying Rose's work as I labored on this book.

Rose has become my artistic mentor, and I have become an ardent student. I have been an oil and acrylic painter for decades, yet from her I have acquired some valuable knowledge about the more effective use of color and the magic of color harmonies. I have learned that Rose's techniques apply to my mediums of choice, though her work has also inspired me to try watercolor.

It is my hope that you will soak up the teachings in this book and be inspired by the art and lessons herein. We all are given a creative urge; may this book help you fulfill your innate desire to create works of beauty and grace.

—Dee Jepsen

THE LITTLE HARBOUR - 30" × 22" (76cm × 56cm)

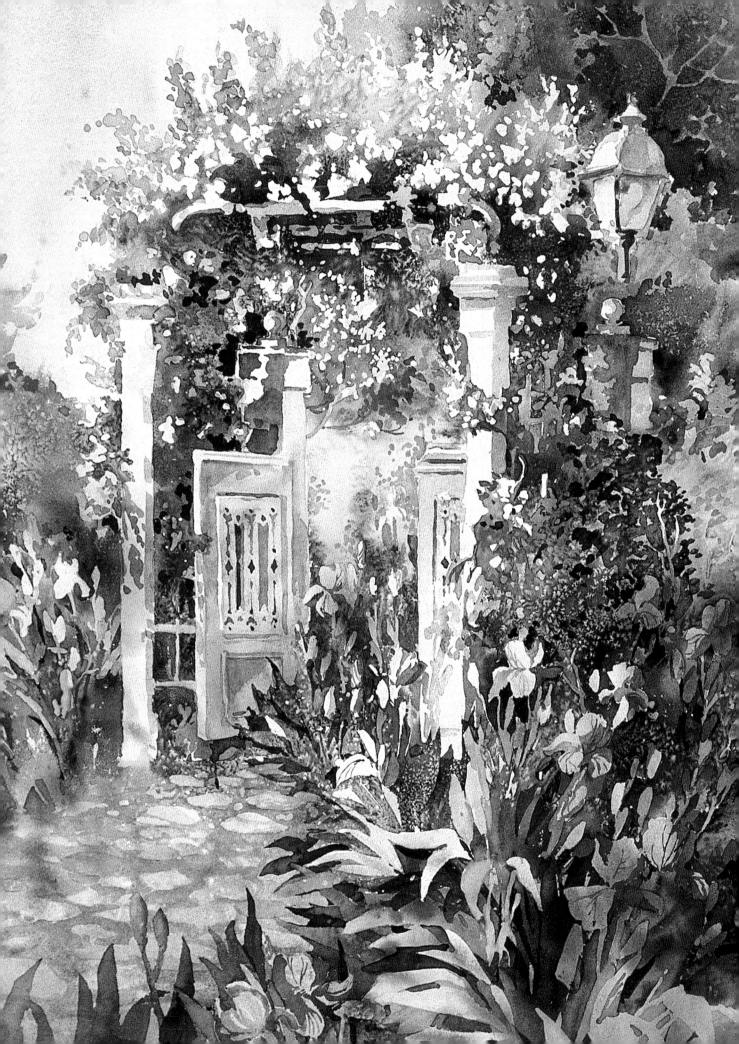

introduction

After receiving my first set of oil paints when I was eight years old, color has been my greatest challenge. I have always struggled to get the desired color. My interest in color led me to the challenge of painting in transparent watercolors. In my search for the perfect medium, I discovered that watercolor could achieve the most beautiful results when it came to color.

While visiting galleries in the United States and Europe, I found myself drawn to the Impressionists. As I studied these paintings, I felt an excitement in viewing their colors from a distance. Drawn into the paintings, I observed the artists would put one color next to each other and would use analogous colors and color complements to create a varied but harmonious effect. I also discovered that they used pure color to keep the hues brilliant.

As an artist, I can only begin to duplicate the majesty of God's creation. Through years of painting with watercolor, I have discovered that color needs to be interpreted. That is, when we look at an object's local color, like the green shade of grass, we can see that there is more to the green and just one monochromatic hue. In the sunlit areas, the grass may appear more yellow, and in the shady areas, it may appear more blue. If we use these colors together—yellow for the lights, green for the midtones and blue for the shadows—these colors will create a harmonious whole. Why? Because these colors are analogous to each other on the color wheel; they create color harmony, meaning they all blend together to create a pleasing and consistent arrangement of color.

Of course, there is more to a painting than color. Drawing and composition are also very important, and I believe anyone can learn to draw meaningful compositions. There are many different techniques that can add texture and interest to your painting, so long as you're open to surprising possibilities.

To me, subject matter isn't nearly as important as shapes, illuminating color and the contrast of dark shades interlocking with light color. I hope you will enjoy each study, each technique, each experiment in this book, and, above all, enjoy the wonderful color you can achieve.

—Rose Edin

THE GATE - 30" × 22" (76cm × 56cm)

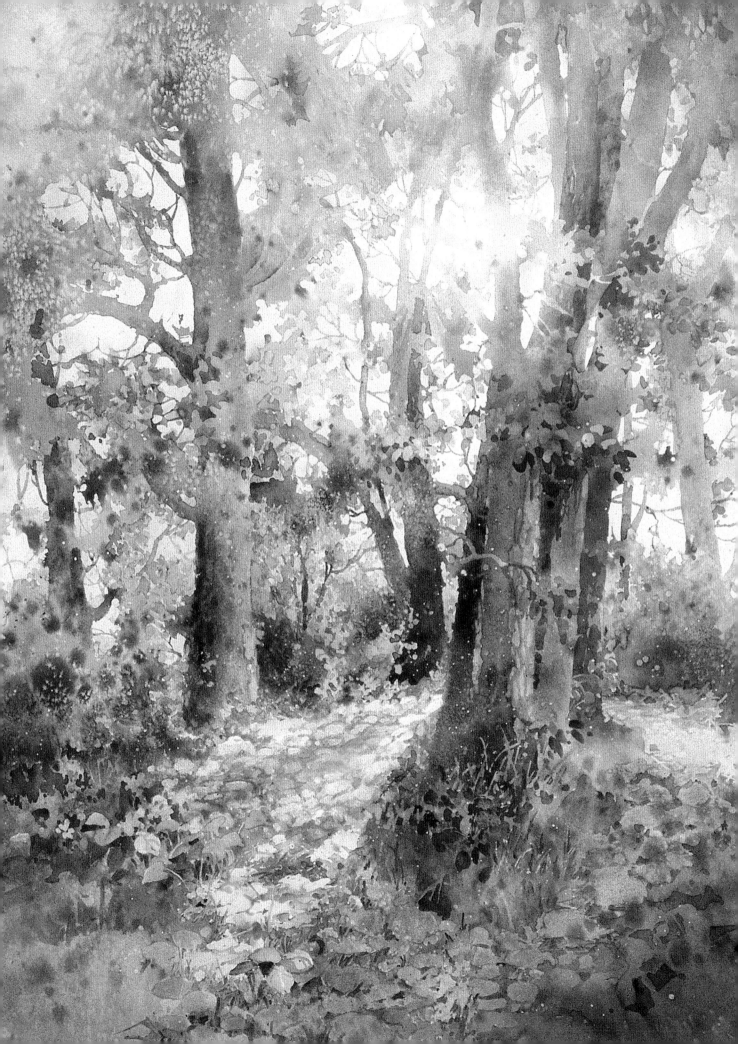

materials for getting started

Although many think the longevity of a watercolor is very short, and it will soon fade and lose its vibrancy, that is not true with the materials available today. If you use professional-grade pigments and acid-free watercolor paper, not only will you achieve improved results, you'll also keep your paintings looking beautiful for years to come.

Adam's mark. The Creator's touch.
The soul's divine tattoo.
It is an image that enables Eden's children
To imagine and create.
It is what animates all who paint or sketch
And is reflected on their canvases and prints.
It is the Hand of God upon the Garden prince
That has touched you with desire
To make your mark upon the world
And help it see the Light.

—Greg Asimakoupoulos

CREATION LIGHT - 30" × 22" (76cm × 56cm)

where to work

If you are a beginning watercolor painter, you will be surprised at what you can do with the right materials and setup. An important but often overlooked "tool" for painting is simply having a place to paint.

If you're lucky enough to have a dedicated studio, it's wonderful to have northern light, which allows you to see the truest colors. I have to make my studio a lot of different places, particularly when I am teaching. Here are a few basic things you'll need for your painting area:

- **Space.** Your studio can be as simple as a corner of your table, or a room dedicated only to painting. The main requirement is having a space to leave your materials out undisturbed, ready to use when inspiration strikes.

- **Table or other flat surface.** You can invest in an artist's table that tilts toward you. These tables make it easier to do some of the drawing and painting, particularly with large pieces. Really, though, any flat, sturdy surface that you don't mind getting some paint on will do.

- **Light.** Try to set up near a window, but if that's not available, a halogen light or combination fluorescent and incandescent light is also good.

En Plein Air Painting

If you're going to paint on location, travel light. I often sit on a rock or curb or on a 2-lb. (1kg) stool I can sling over my shoulder. I set as many items on the ground as I can, secure the paper to my support and use my legs as a table.

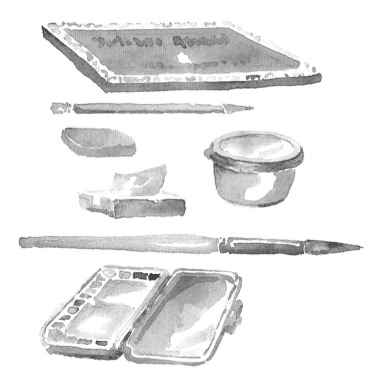

Keep Your Pack Light for Plein Air Work
I keep the following items in my totebag, as you never know when inspiration may strike: a small watercolor palette filled with dried paint, one no. 18 round brush, water container with lid, pencil, eraser, sketch pad, permanent ink pen, 140-lb. (300gsm) watercolor paper block and facial tissue. My stool and the items in my totebag weigh less than 5 pounds (2.3kg).

paper

You can find watercolor paper in a variety of weights and textures. Whatever kind of paper you choose, make sure it's acid-free. Selecting acid-free paper will help preserve your painting and keep it as beautiful as the day you created it.

I like to use either 300-lb. (640gsm) or 140-lb. (300gsm) cold-pressed paper and 140-lb. (300gsm) watercolor block by Arches. I prefer to use cold-pressed paper because it has a little tooth, or texture, and absorbs the paint better than hot-pressed paper, which is very smooth. Cold-pressed paper is also good to use with masking fluid because the paper has enough sizing to allow the masking fluid to be easily removed.

I've found it's more cost-effective to buy paper in 22" × 30" (56cm × 76cm) 300-lb. (640gsm) or 140-lb. (300gsm) sheets, and cut it into smaller sizes if necessary. If you're painting on location,

though, use a block of watercolor paper. A block of watercolor paper has up to twenty pages of paper adhered to stiff backing and does not have to be stretched.

An advantage to using 300-lb. (640gsm) paper is that it doesn't buckle, so it doesn't have to be stapled to a support and taping it down is optional. The 140-lb. (300gsm) paper, however, will need to be stretched before use or it will buckle.

In addition to watercolor paper, you'll also need:

- **A support**, which is what your watercolor paper rests on as you paint. Typical supports include ⅜-inch (1cm) plywood board or foam core, which can be found in art supply stores.

- **A stapler** for securing your watercolor paper to a plywood board. Use staples that aren't any deeper than ⅜-inch

(1cm), or they will come out the other side of the board.

- **Masking tape** for securing paper to your support. Select a masking tape that's at least 1½-inches (4cm) wide. For 300-lb. (640 gsm), masking tape is all you need to secure it to the support. If you're using 140-lb. (300gsm) paper, you can apply masking tape over the stapled area after the paper has dried.

- **A sketch pad** for getting down quick impressions while working on location or in your studio.

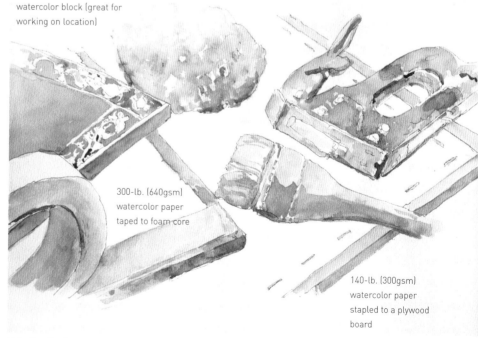

watercolor block (great for working on location)

300-lb. (640gsm) watercolor paper taped to foam core

140-lb. (300gsm) watercolor paper stapled to a plywood board

Painting Surfaces and Supplies

brushes

Having the right brushes makes your painting process so much smoother. I use only a few large brushes for most of my work. I use:

- **Rounds.** A good round brush can hold a lot of water and cover a lot of area with paint, yet because of its pointy tip, it can also get into finely detailed areas. I use size numbers 16 or 18 rounds.

- **Hakes.** Hakes are oriental brushes with short, flat bristles. They're great for large washes or for painting or wetting a large area. I usually use 2-inch (51mm) or 3-inch (76mm) hakes.

- **Riggers.** A rigger, or liner, is a thin brush with long bristles. I use a size no. 4 rigger to apply masking fluid because I can easily control where it's applied, especially in intricate details.

Additional Painting Materials

Brushes aren't the only things you can use to manipulate and apply paint. Here are a few other items that will help you achieve the results you want:

- **Toothbrush.** I use a toothbrush to scrub out paint for fixing mistakes or softening a hard edge.

- **Spray bottle.** Any plastic bottle that sprays a fine mist is a great tool for wetting large areas of your paper.

- **Masking fluid.** A must for saving the white areas of your paper. It comes in clear and a variety of colors (see pages 20–21 for more on masking fluid).

- **Soap.** You'll need either a bar of soap or liquid soap to coat your rigger before applying masking fluid. The soap will protect the bristles from the masking fluid and make it easier to clean the brush.

drawing materials

Before I paint, I sketch my composition with a 3B pencil. When working on location, however, I often use a fine line permanent pen.

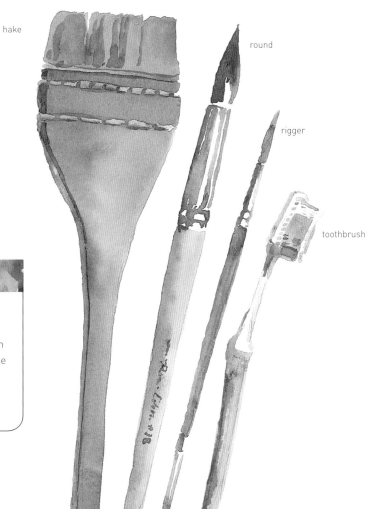

hake

round

rigger

toothbrush

paints

Use a transparent, permanent watercolor paint. Transparent pigments let you see the underlying layers of paint, which allows you to build vibrant layers, or glazes, that create a range of values and hues. This is because light passes through the paints and bounces off the white of the paper.

Using professional-grade paints will allow you to create clean, intense colors because the pigment quality is finer than that of student-grade paints. I prefer Winsor & Newton paints in tube form. Six colors form my main palette: Scarlet Lake, Permanent Rose, Cobalt Blue, Antwerp Blue, Winsor Yellow and Quinacridone Gold. For an extended palette, I include Cobalt Violet, Permanent Magenta, Cadmium Orange, Cobalt Green, Cerulean Blue, Burnt Sienna and Indigo. Indigo and Cadmium Orange are opaque colors, which means you can't see through them. Opaque pigments make the transparent pigments seem especially vibrant. In addition to your paints you'll need:

- **Palette with lid:** Select a covered paint palette with small pans, or wells, on the sides for your paints and a large, center area for mixing and liquefying pigment. I recommend a palette with a lid to keep the paint fresh. I like the John Pike palette, but a number of brands are available.

- **Water container with lid:** Use a container large enough to easily clean your brushes so you won't have to change the water as often. Having a lid with your container makes it easy for taking it with you for plein air painting.

- **Paper towels:** Soft paper towels are great for daubing off excess water or pigment. You can also use any soft cotton rag.

- **Extras:** Optional materials such as salt, plastic wrap, gauze, rice paper and acrylic matte medium are great for creating interesting effects.

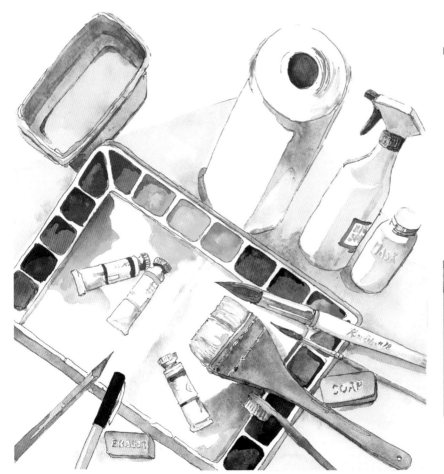

Paints, Palettes and All the Extras

rewetting pigments

When your paints are dried in the palette wells, take a clean, wet brush and stroke each color in the well until the paints are the consistency of cream. Your brush must be thoroughly cleaned between each color.

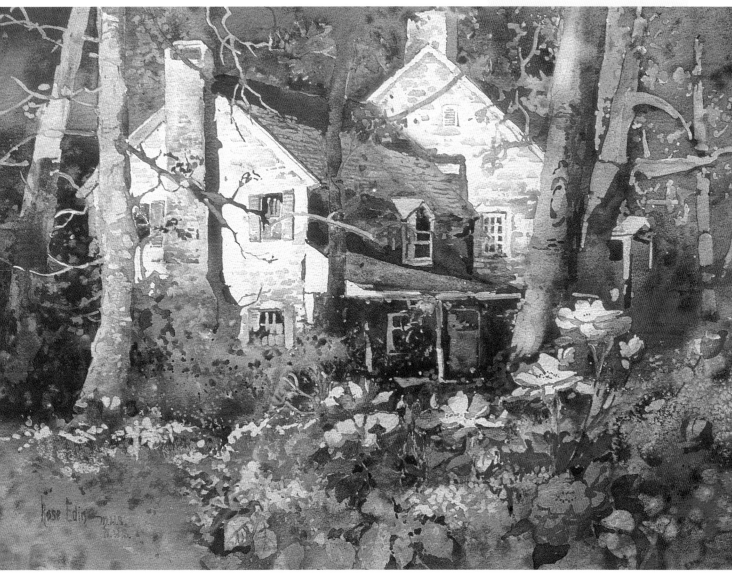

PENNSYLVANIA HOUSE - 22" × 30" (56cm × 76cm)

techniques to enhance your art

The varied techniques available to the watercolorist make this medium so challenging and fun. Sometimes the different textures you can achieve determine the direction the painting will go. The techniques shown in this chapter can beautifully enrich a painting. In my painting *Pennsylvania House*, I used a vibrant underpainting, spattering, liquid mask and salt to achieve the effects I desired.

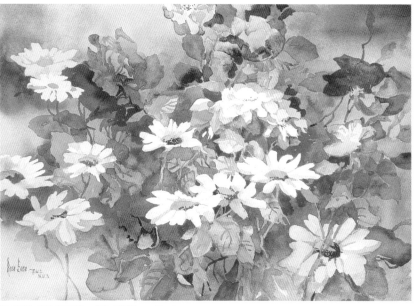

DAISIES AND ROSES - 22" × 30" (56cm × 76cm)

masking fluid

Masking fluid is one of the best tools for watercolorists. It's a sure way to save those whites, lights and pure colors. Masking fluid comes in a variety of brands and colors. Using a colored masking fluid makes it easier to see where you've applied it for easy removal. Try your masking fluid on a scrap of paper before applying it to your painting.

Use your fingers or a masking fluid pickup tool, which is made of crepe rubber. The masking fluid pickup tool can be used just like an eraser. Cut off the areas that get covered in masking fluid with a razor blade.

Apply Masking Fluid Over Dry Paints
I often apply masking fluid over painted areas. Let the first layer dry thoroughly (preferably overnight). Here, I wanted to protect the positive shapes of some flowers and foliage before applying additional colors. After removing the liquid mask, the white areas and the underpainting remained in the shapes of flowers and leaves.

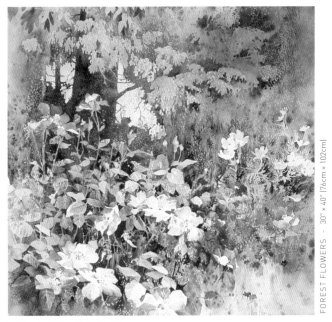

FOREST FLOWERS · 30" × 40" (76cm × 102cm)

Masking Fluid and Supplies
Apply masking fluid with an inexpensive brush, painting knife, toothpick or any sharpened stick. If using a brush, coat it with soap first to minimize the damage to the bristles. The rubber cement pickup will save your fingers—and your surface—as you remove the masking fluid.

White Isn't the Only Light
Notice I left some whites in the flowers to suggest the lightest light. I also applied light oranges, reds and violets to the flowers instead of just pink. These color harmonies also make the flowers vibrate with light.

20

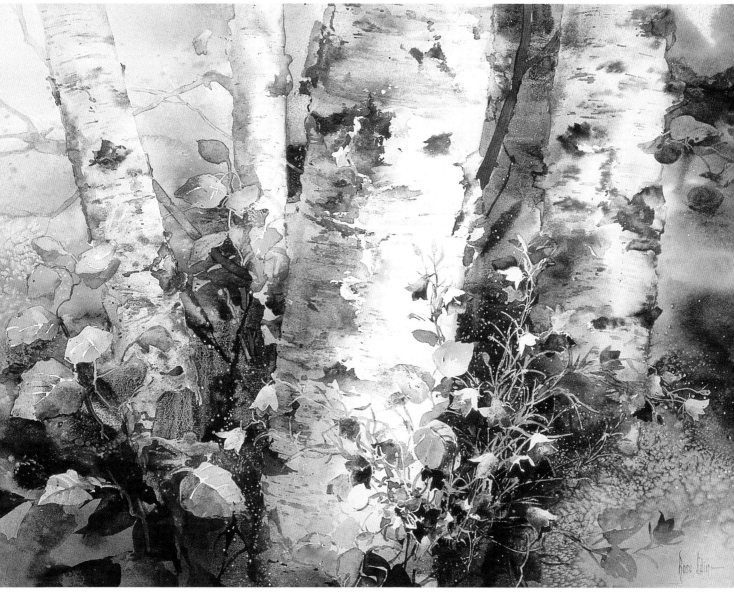

Save Whites and Other Important Areas With Masking Fluid
After painting the tiny flowers, some of the leaves and the tree, I
applied masking fluid to protect these areas after they had dried
completely. This gave me complete freedom to apply large amounts
of juicy yellows, greens and blues. I even threw in a little salt for
texture (see page 26).

BIRCHES AND BLUEBELLS · 22" × 30" (56cm × 76cm)

multicolored underpainting

Try a soft underpainting using the primary colors of yellow, red and blue. Leave your intended center of interest the white of the paper, then apply a diluted yellow next to that, then the red and finally the blue. I've found this underpainting pulls the subsequent colors together and softens the colors that appear outside the white area.

Before you begin, dilute your colors on your palette until they are the consistency of cream.

materials list

PIGMENTS
Cobalt Blue, Permanent Rose, Winsor Yellow

SURFACE
140-lb. (300gsm) cold-pressed watercolor paper

BRUSHES
2-inch (51mm) hake, no. 16 or 18 round

OTHER
Spray bottle filled with clean water

1 Wet the Surface and Apply Yellow
Brush clean water over the entire surface, even the areas you want to leave white, with the 2-inch (51mm) hake. Tip your paper to remove excess water. Using a no. 16 or 18 round, apply Winsor Yellow around your intended center of interest.

2 Apply Red
Clean your no. 16 or 18 round and load it with the diluted Permanent Rose. Apply this next to the Winsor Yellow, leaving the center of interest white.

3 Apply Blue
Clean the round brush again and load it with Cobalt Blue. Apply this next to the Permanent Rose and to the edge of the paper. If the surface starts to dry, mist it with clean water from the spray bottle.

4 Tip the Paper and Spatter for Interest
While the surface is still wet, tilt the paper, letting the colors mix and mingle slightly. With a clean no. 16 or 18 round, spatter the surface with the Winsor Yellow, Permanent Rose or Cobalt Blue for interest. Lay flat to dry.

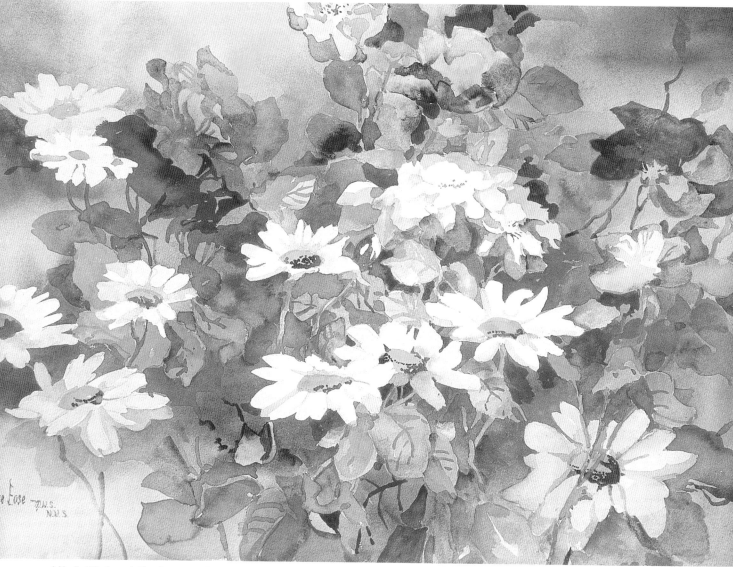

A Varied Underpainting Creates a Cohesive Whole
For this painting, I knew the white daisies would be the center of interest, so I created a multicolored underpainting accordingly. Once the underpainting was dry, I sketched my composition with a pencil. Notice how the spattered pigments suggest additional petals in the background.

DAISIES AND ROSES · 22" × 30" (56cm × 76cm)

spattering

Spattering paint is best when the water-color paper is still wet. If your paper has dried, wet the entire paper with your spray bottle before you begin to spatter. Load your round with some juicy water-color, hold the brush at a right angle to the paper, and tap.

23

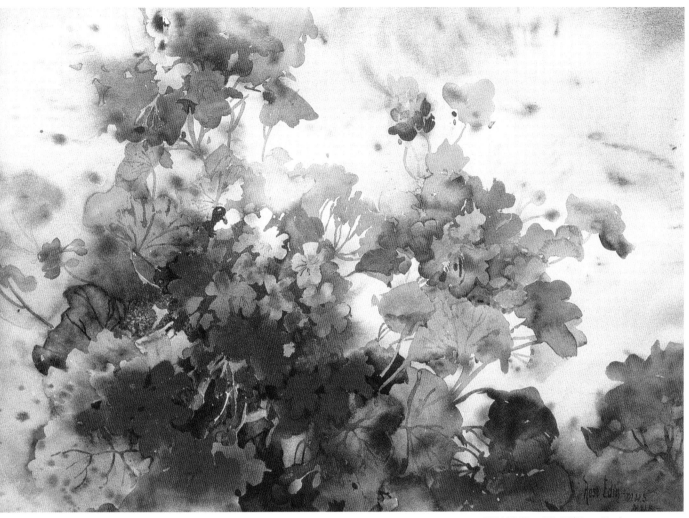

Spattering and Underpainting

The brightness of the Scarlet Lake stands out beautifully against the muted tones of the underpainting. For interest, I also spattered paint onto the darkest shapes behind the flowers.

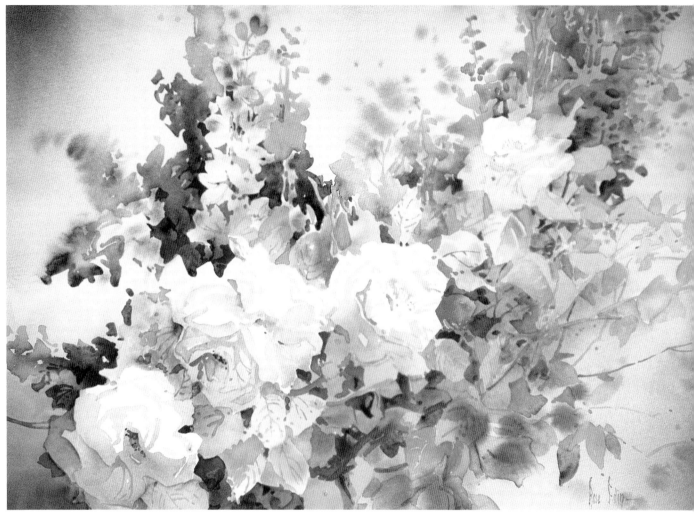

ROSES AND DELPHINIUM - 22" × 30" (56cm × 76cm)

Plan for the Center of Interest

Since the roses in this painting were arranged in a diagonal shape, I had to plan the underpainting accordingly. I left the white of the paper in the same diagonal shape as the rose shapes.

To get the background effect, I wet the area from the edge of the leaves to the edge of the paper, then used Cobalt Blue to create the soft, misty illusion of delphinium in the distance. This created a nice contrast to the sharp edges created in the foreground.

tools and techniques for texture

Salt

Salt creates texture that can add interest to an area. Simply sprinkle salt onto wet paint. The salt will absorb the paint, and once the paint dries, brush the salt off to reveal the wonderful texture underneath. Try applying salt in grassy foregrounds, bushes and, sometimes, trees.

TIPS FOR USING SALT

- **Keep the working area wet.** Give yourself more control over where the salt works by having only the working area wet.

- **Try different types of salt.** Salt comes in different sizes. Table salt is very fine and will create fine spots on your surface. Kosher salt is larger and will create larger spots. Sea salt is irregularly shaped and will produce corresponding patterns.

- **The more salt you apply, the more texture it creates.** Each salt crystal creates a spot. The more concentrated your application is, the more concentrated the spots will be.

- **Experiment with the time between applying paint and applying salt.** On a piece of scrap paper, try sprinkling on salt immediately after you apply paint and see the effect it creates. If you wait a little longer to apply the salt, you'll get a different effect.

- **Let the paint dry completely before removing salt.** If any salt residue remains, carefully pat the area with a clean, damp brush, then use a facial tissue to remove the remaining granules.

Table Salt Leaves a Fine Texture
Salt isn't just for seasoning food; it also creates interesting and varied textures when sprinkled onto wet paint.

Applying Salt
For salt to work, the area you're applying the salt to needs to be wet. I like to apply salt when my surface is shiny, but not runny. Salt won't have any effect on dry areas. Just make sure you've removed all the salt before painting other areas.

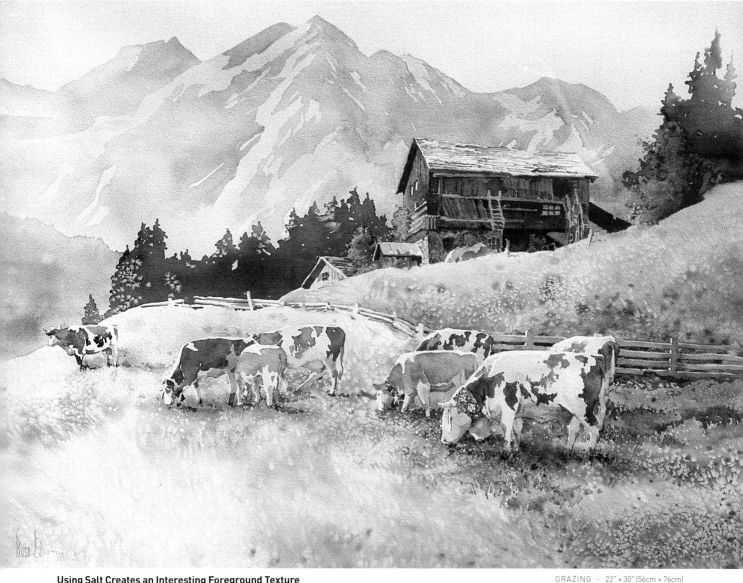

Using Salt Creates an Interesting Foreground Texture
To make the cows stand out, I used a very light value near the barn and a deeper value in the right foreground. After trying the salt technique on a separate sheet of paper, I felt confident in applying the salt to these areas in the painting.

GRAZING - 22" × 30" (56cm × 76cm)

Gauze

If you want colorful textures, try using cotton gauze. I prefer cotton gauze that you can find in a hardware or paint store, but medical gauze from a grocery store or pharmacy can work, too, with a little more effort.

TIPS FOR USING GAUZE

- **Use different sizes.** You can use gauze to create interesting background effects over an entire painting, or cut small pieces of gauze with scissors for use in selected areas.

- **Vary the texture.** Pulling and poking holes in the gauze will create varied and unique textures.

- **Wet the surface first.** Apply clean water to your surface with a brush or a spray bottle so the gauze will stick to the paper. If the gauze and the paper start to dry, rewet

Cotton Gauze
There are many ways to create texture in a painting. One of my favorite techniques to use is applying cotton gauze.

the area by misting it with a spray bottle.

- **Apply thick fluid colors.** When working with gauze, you may have to use a higher pigment-to-water ratio than you normally do. Experiment on a piece of scrap paper until you're comfortable with the effects.

- **Work carefully to avoid disturbing the gauze.** Even though the water helps the gauze adhere to your surface,

you can easily move the gauze with your brush. Keep your strokes delicate so the gauze stays in place.

- **Lay the painting flat to dry before removing the gauze.** Make sure the paint has dried completely, then carefully lift the gauze to reveal the surprising texture underneath.

Experimentation Is a Must
To create this effect, apply your colors next to each other on the wet paper and gauze, then tip the entire painting so the colors run together. The colors mix on the paper rather than on the palette and look so much more vibrant.

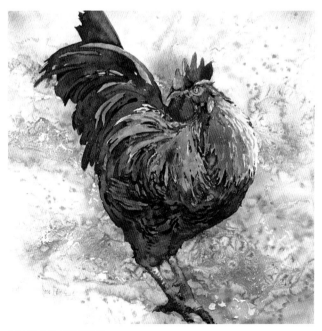

A Varied Background
Here I used gauze to suggest the appearance of dirt ground surrounding this rooster.

KING OF THE HILL - 22" × 23" (56cm × 58cm)

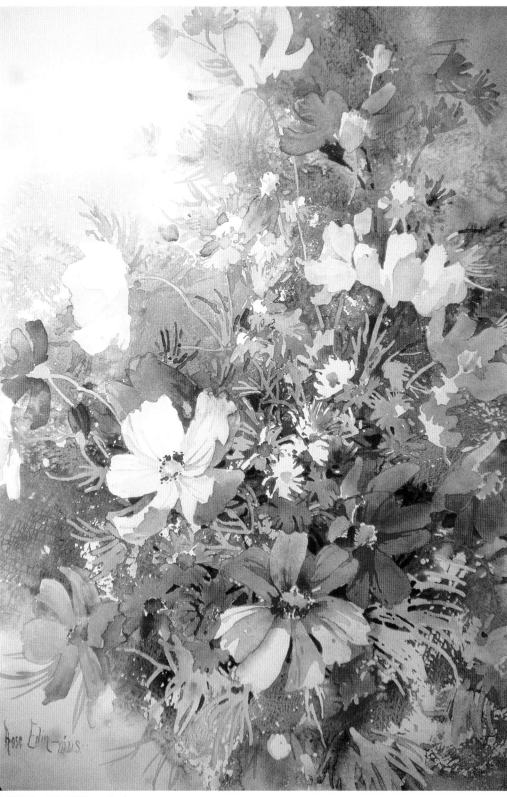

Use Gauze for Stunning Background Texture

I first painted the cosmos and a few of the light asters, then masked this area after letting the paint dry completely. Once the masking fluid was also dry, I added the cosmos leaves and some darker asters. While this was wet, I laid gauze over the entire area and applied yellows, blues and reds over the gauze. I then tipped the surface, letting the colors run together to create an intricate background design.

COSMOS – 30" × 22" (76cm × 56cm)

Plastic Wrap

Different subjects require different textural approaches. Try using plastic wrap to simulate the texture of rocks and rushing water or to simply create an interesting background effect.

TIPS FOR USING PLASTIC WRAP

- **Apply plastic wrap to a wet surface.** Your surface should be wet with paint or water. As with salt, you can alter the effect plastic wrap has on your surface by varying the time between applying paint and applying plastic wrap.

- **Manipulate plastic wrap for best effect.** Pull the plastic wrap in different directions before applying it to your surface. The plastic wrap should look wrinkled when applied to the paper. Once you've laid plastic wrap down on your surface, you can continue to move it until you get the effect you desire. Keep in mind that the paint will be lighter where the plastic wrap is raised and darker where it touches the surface.

Your Kitchen Can Provide a Treasure Trove of Textural Tools
What other painting supplies are hiding in your kitchen? In addition to plastic wrap, try wax paper for a more muted effect.

Applying Plastic Wrap
Here I applied watercolors, then placed plastic wrap I'd stretched and manipulated over that. After letting the surface dry thoroughly, I carefully removed the plastic wrap to reveal these wonderful results.

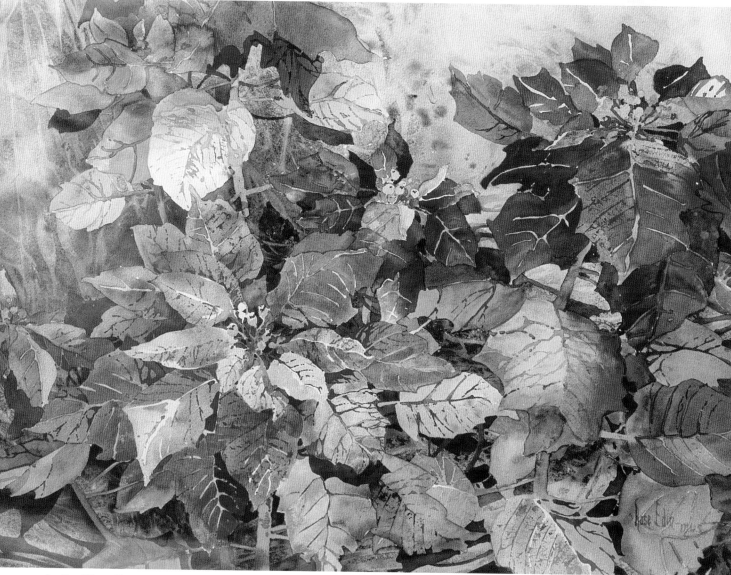

Another Way to Use Plastic Wrap
In this painting, I created the poinsettia flowers first. I then applied juicy watercolors to one section of the background at a time as I worked around the center of interest. While the paint was still wet, I applied plastic wrap over each area, gently pulling the plastic wrap in the directions I wanted.

POINSETTIA – 22" × 30" (56cm × 76cm)

use masking fluid to protect important areas

I could have applied masking fluid around the edge of the flowers and leaves to protect them from any paint that might accidentally land on them in this process. If there's an area you wish to protect from any "happy accidents," apply masking fluid to keep the area looking the same.

rice paper

Rice paper can be used in a collage-type manner to soften an overly bright painting or area of a painting. If you tend to be bold with color, this may become one of your favorite techniques.

There are all kinds of rice paper available, so experiment to see which type might be best for you. I like to use Unryu rice paper, which I secure to my surface with acrylic matte medium. (Notice the beautiful texture of the rice paper itself.) To secure rice paper with matte medium, dilute the matte medium with water, then brush it on the rice paper and the watercolor paper with an old brush. The matte medium will dry to a translucent matte finish.

Acrylic Matte Medium
Because acrylic matte medium dries to a clear matte finish, it blends in perfectly with the rest of your composition.

Rice Paper Has a Delicate Texture
Unryu rice paper can be found in art supply stores. Notice the long wispy fibers running throughout the paper that add an interesting textural element.

creating contrast

Rice paper is a great way to add contrast to your paintings. Tear it into various shapes so that you can mute some of the areas in your painting while leaving the center of interest bright and vibrant.

Applying Rice Paper
Once you figure out where you'd like to apply the rice paper, mist it with water from your spray bottle to hold it in place. Use an old brush to apply diluted matte medium over the rice paper and the surface. For large areas you can pour the matte medium so long as you work rapidly. When finished, wash your brush thoroughly with soap and water. Once the surface is dry, you can paint over the rice paper.

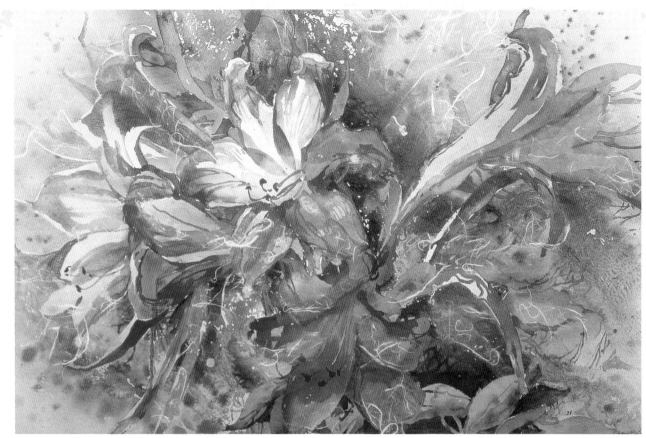

LILIES - 22" × 30" (56cm × 76cm)

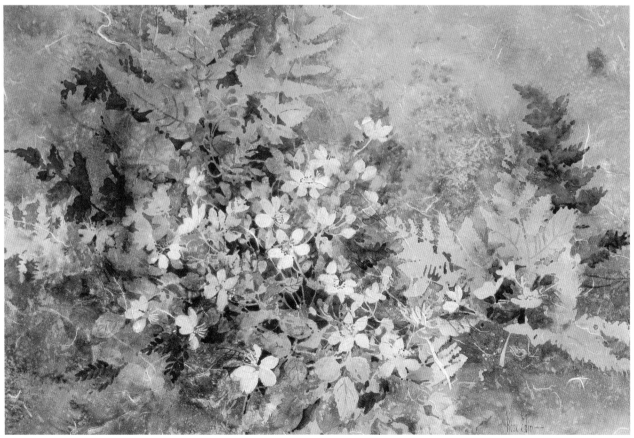

FOREST BOUQUET - 30" × 40" (76cm × 102cm)

using vignettes

The word *vignette* means "vine tendrils that form a border." In painting, its definition is "to shade off gradually," as to not leave a definite line on certain areas of the border of the painting. In other words, to have the painting fade away in areas toward the border. When you are working on a vignette, first think about the center of interest and all the components that are closest to it, as these areas should have the most detail. The level of detail will fade as you move closer to the edge of your surface and away from the focal point.

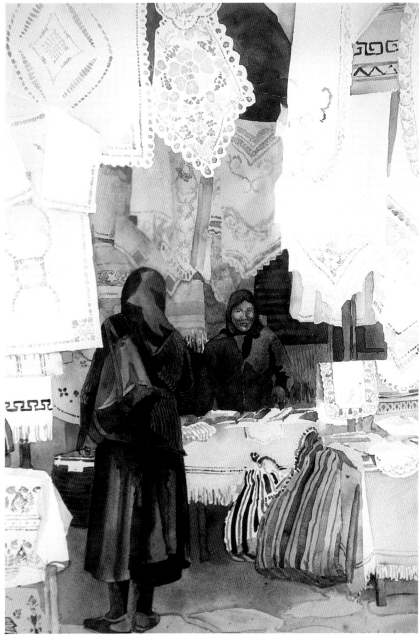

THE LACE SHOP - 30" × 22" (76cm × 56cm)

A Natural Vignette
When I walked into this lace shop on the island of Crete, I noticed the lights and darks created a natural vignette. For the painting I had to think carefully about where to allow the darks to go off the paper. I slowly built up the women and the background in dark layers. I created the light lace shapes in an abstract pattern to lead the viewer's eyes into the painting.

vignette

A vignette is a composition in which the painting fades off in two or three areas. Vignettes can be designed symmetrically so that the edges fade in a circular or rectangular shape, as is traditionally the case with portraits. Vignettes can fade off unevenly, creating a more organic feel perfect for landscapes.

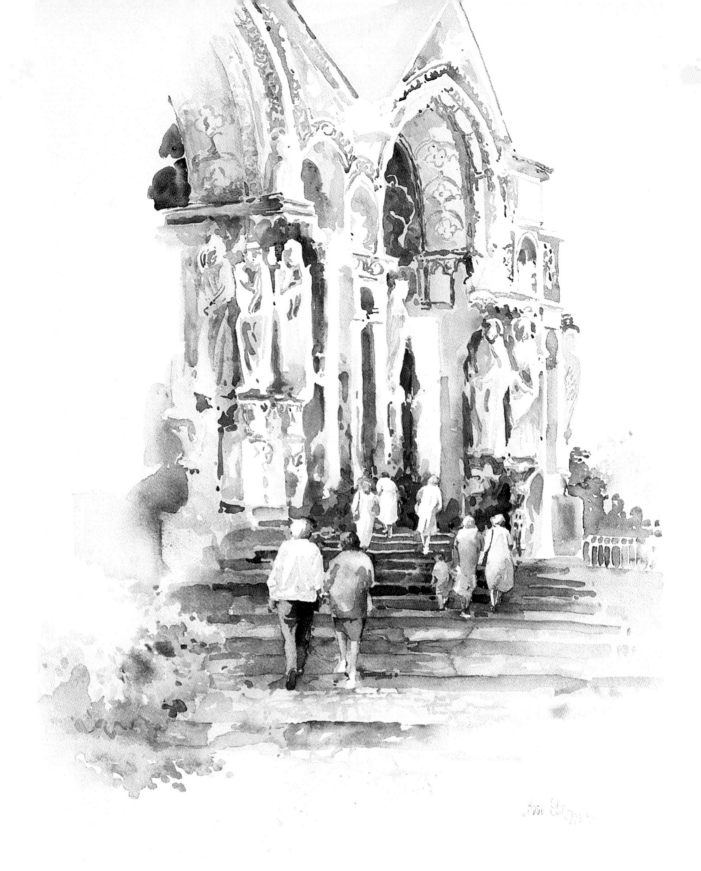

Vignettes Are a Handy Shortcut for a Quick Composition
A shortcut in plein air painting can be created by leaving a good deal of white around
your painting, thereby creating a vignette. You must, however, have a clear sense of the
interest area. Here I left three corners unpainted.

NOTRE-DAME DE CHARTRES - 24" × 18" (61cm × 46cm)

fixing mistakes

Sponges, scrubbing brushes and tooth-brushes are wonderful tools for lifting watercolor pigment that you've already applied. But what do you do when an entire area needs to be reworked? Using a cleaning eraser, found in the cleaning aisle of your grocery store, is just what you need to easily remove large sections of a painting. Simply wet the eraser and squeeze out the excess water. Rub the cleaning eraser across the area you want to remove, let your painting dry, and start all over again.

Use a Cleaning Eraser to Fix Mistakes or Make Adjustments
Cleaning erasers come in blocks about the size of a bar of soap and can be cut into smaller shapes and sizes with a pair of scissors.

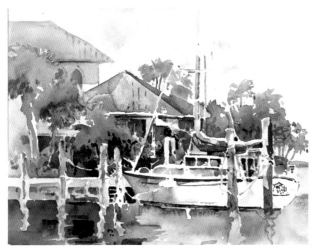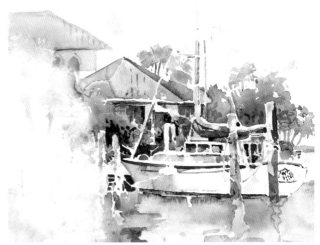

Allow Yourself a Second Chance
After a quick plein air painting on a wharf, I realized the values had been painted too dark on the left-hand side of the composition. A cleaning eraser came to the rescue. Once the surface was dry, I simply repainted that area.

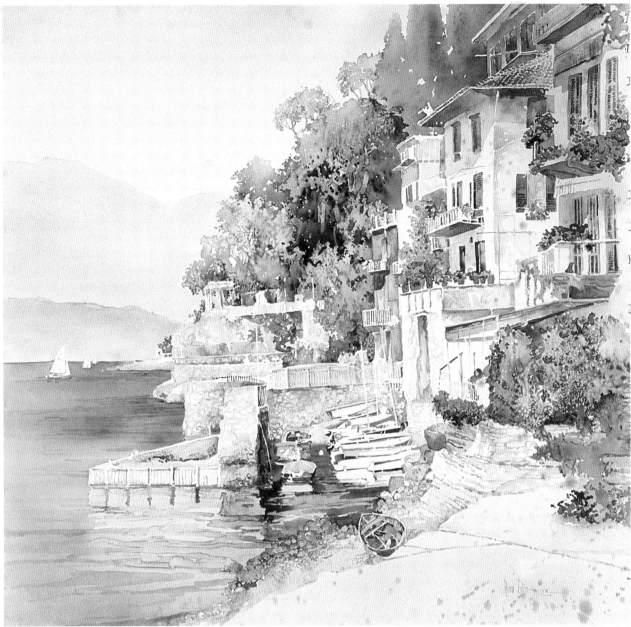

The Smallest Details Can Make the Biggest Difference

Feeling very inspired after spending over a week on Italy's Lake Como, I launched into this large painting. After the painting was framed, I had a nagging feeling that something was missing and realized the painting would be improved if some sailboats were added to the composition.

I applied masking fluid around the area I wanted to rework, thereby protecting the surrounding painting. I let the masking fluid dry overnight. Once the area was lifted, I created the sailboats and removed the masking fluid from the surrounding areas.

LAKE COMO – 34" × 38" (86cm × 97cm)

using a toothbrush to lift an area of a painting

Dip a toothbrush in clean water and gently scrub the area you wish to lift (you may need to mask the surrounding areas to protect them). Blot the color out with a paper towel. Repeat the process until the paper returns to white. You do not need to scrub hard, just repeat the process several times to remove the pigment.

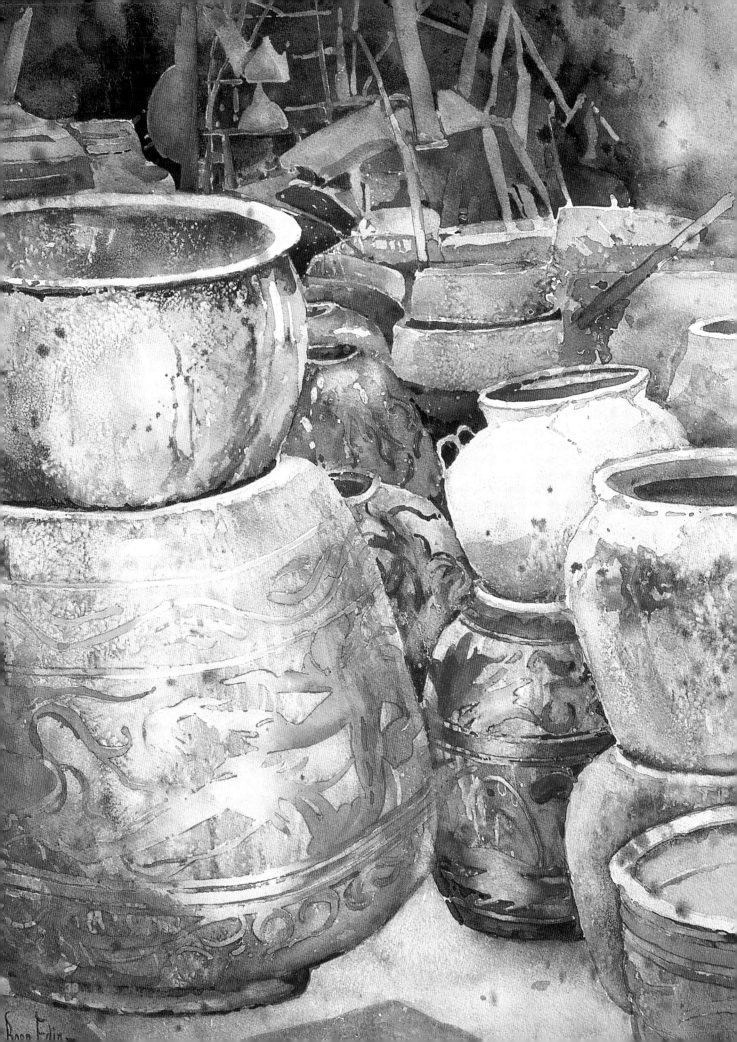

drawing
& composition

I believe that everyone can learn to draw, and you can use many techniques to enhance your drawing skills. Thinking of your subjects in terms of shapes can help you simplify your subject matter. Working from photographs and using a grid to draw your subject on your watercolor paper are two key tools for improving your drawing and creating an interesting composition.

An antique shop in Hangzhou, China, was the inspiration for *Chinese Patina*. Walking around the shop, I came upon a huge pile of old pots that looked as though they had been there for years. I took many photographs of them, which I later used to form the basis of the composition.

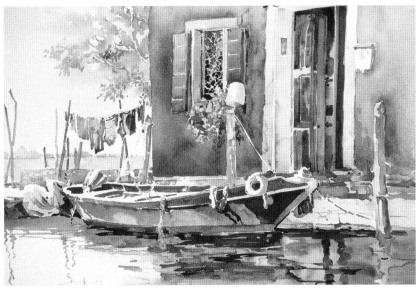

CHINESE PATINA – 30" × 22" (76cm × 56cm)

BURANO – 18" × 24" (46cm × 61cm)

39

stencilling positive and negative shapes

Using stencils is a great way to create a realistic shape without having to draw it freehand. I often use ferns, flowers and leaves from my garden to create realistic, yet organic, positive and negative shapes. Positive shapes consist of the subject area of your painting; negative shapes are the areas around your subject. To form a negative shape, this same leaf can be used as a stencil. Load the brush with fluid paint and lightly stroke it over the leaf. Take the fluid paint all the way to the edge of your painting.

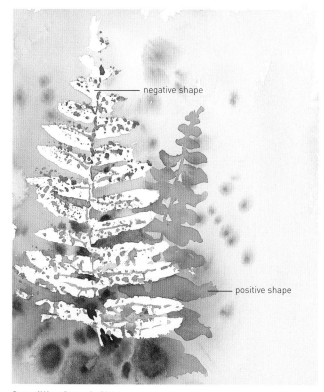

negative shape

positive shape

positive and negative space

Painting positive space is often called direct painting. Painting the area around the subject is referred to as indirect painting.

Stencilling Organic Shapes
I used the leaves of a fern as a stencil to create positive and negative shapes. To create the negative shape, lay the leaf on your paper and paint the area around it. Here I went as far as the edge of the paper. To create a positive shape, trace around the outside of the leaf and apply paint to the traced pattern.

Beyond ferns, leaves and flowers, wax paper and freezer paper also make good stencils.

Direct and Indirect Painting
I used both direct and indirect painting on the ferns in this piece. The ferns painted indirectly form a nice frame around the flowers and leaves of the piece, while the ferns painted directly create a nice color contrast for the red flowers.

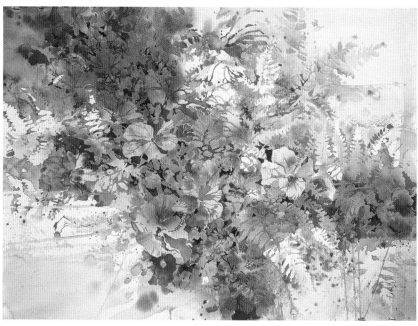

FERNS AND FLOWERS - 24" x 32" (61cm x 81cm)

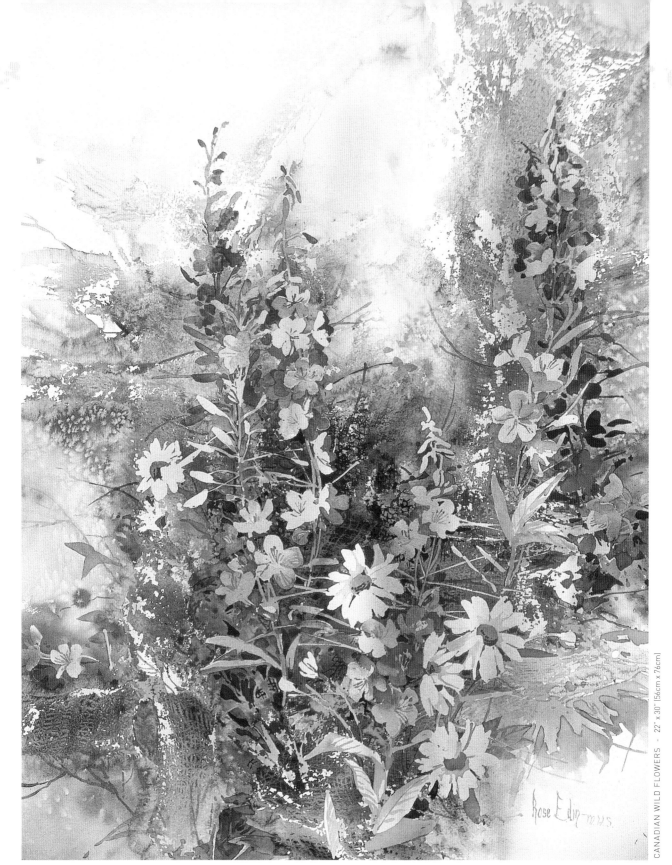

CANADIAN WILD FLOWERS – 22" x 30" (56cm x 76cm)

Arrange, Then Trace

Here I used some of the wildflowers growing around my home as stencils for this piece. I started by tracing the largest flowers, then moved to the smaller flowers and leaves. I used direct and indirect painting to define the flowers and leaves.

using a grid

Placing a grid over your reference photograph can help you successfully transfer the subject in your reference photo onto your painting surface. The grid simply helps you break your subject down into manageable chunks. To further simplify the subject, make a photocopy of the reference photo and draw the grid over that. Using a black-and-white photocopy removes the complexity of color and allows you to easily see where the light and dark areas are.

Tips for Using a Grid

- **Make a black-and-white photocopy of your reference photograph.** If necessary, adjust the contrast setting on the photocopier to make some details lighter or darker.

- **Use a ruler and a pencil to draw a grid on your photocopy.** I usually divide my reference photograph into four sections. However, you can double or triple that number if you'd like to simplify the drawing even further.

- **With the ruler and pencil, copy the grid onto your painting surface.** It's important that the grid on your painting surface be in proportion to the grid on your photocopy for ease of transfer.

- **With a pencil, copy the subject over to your painting surface.** Simply focus on drawing one section at a time.

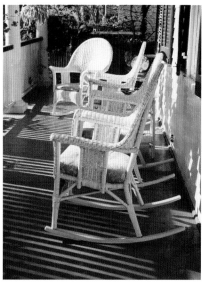

Reference Photograph
Select a photograph of a scene that interests you.

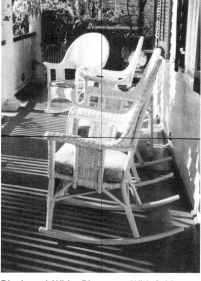

Black-and-White Photocopy With Grid
Using a photocopier, create a black-and-white photocopy of the reference photo. Using a marker, pen or pencil, create a grid over the photocopied image. Here, I just did four simple squares.

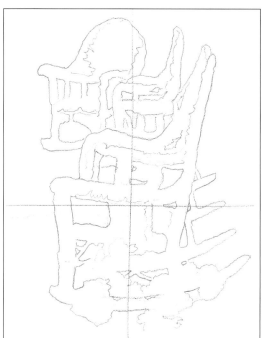

Draw the Shapes Within the Grid
When I use the grid method, I almost always draw the image upside down and sideways, focusing on one section at a time. Sometimes you may be drawing a dark or light shape without identifying what it is, but it will make sense when the other sections are completed.

Your photograph and your painting surface must be in the same proportion. For instance, if your photograph is 5" × 7" (13cm × 18cm) your surface could be 5" × 7" (13cm × 18cm), 10" × 14" (25cm × 36cm), 15" × 21" (38cm × 52cm) and so on.

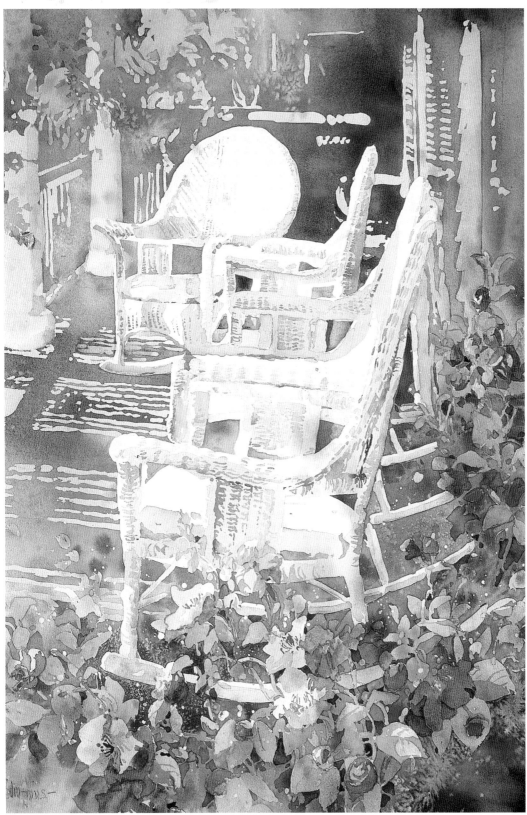

A Strong Painting Starts With a Strong Drawing
Using a grid to complete the drawing really helped me capture the details and perspective in this piece. It was especially helpful in capturing the patterns of light and shadow, which I then replicated in this painting.

THE PORCH - 30" × 20" (76cm × 51cm)

composing with your camera

Reference photos are wonderful in that they capture a specific moment in time, which allows you to carefully examine your subject and spot interesting areas you may not have noticed before. For this reason, it's a good idea to take several reference photos of your subject as this will help you document lots of interesting possible subjects. Photograph the entire subject as well as interesting parts of the scene to record necessary details.

Gather Many Details With Your Camera
Before drawing, look at all the options. This whole area was filled with interesting subjects, but with the light shining behind the building, I couldn't help but be drawn to the arch, roof and flowers.

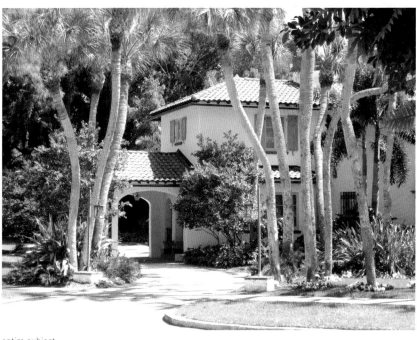

entire subject

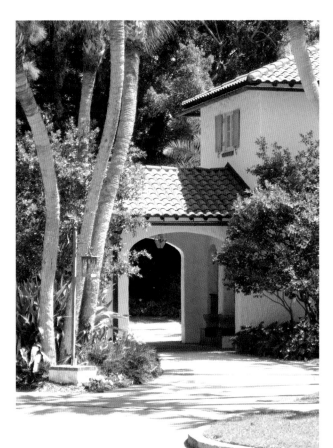

detail of entrance

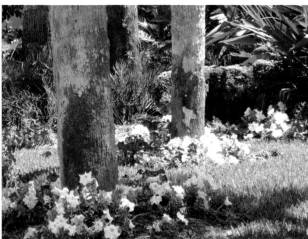

detail of light and shadow patterns on foreground flowers

focal point

The focal point is the area in your painting that you want the viewer to concentrate on, as it's the most important visual element of your painting. Other elements in the painting should draw attention to this area.

creating a strong composition

You can work with the best materials in the world, but if the composition is weak, your painting will always seem to be a little bit off. You can strengthen your compositions by including:

- **Interesting shapes.** Your subject itself should have interesting shapes and so should the negative shapes surrounding it, including the background and shadows. A variety of well-placed shapes can help lead the viewer's eyes to the focal point. Overlapping shapes and shapes that disappear and reappear also keep the viewer's eyes engaged in your painting.

- **A consistent light source.** A strong light source creates the illusion of depth and can add a sense of drama. Keeping the light consistent also makes your painting more believable.

- **Repeating colors and/or shapes.** This repetition gives the painting a feeling of rhythm and harmony. The rigid, geometric shapes of buildings along a skyline or the rounded organic shapes of a landscape create a sense of harmony that can lead the viewer's eyes to the focal point.

design and composition

Design—placing of pictorial elements within a given format.
Composition—selecting a combination of shapes form composition.

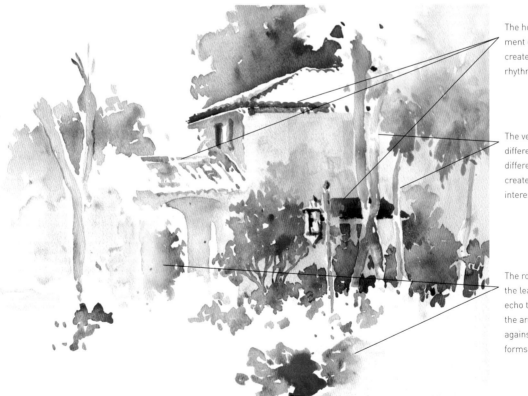

The horizontal movement of the rooftops creates a sense of rhythm.

The vertical trees in different sizes and in different placements create a variety of interesting shapes.

The rounded shapes of the leaves and bushes echo the shape of the arch and contrast against the angular forms of the house.

Paint the Closest Items First
Here's the initial stage of a painting based on the reference photos on page 44. Even though I worked from photographs, I took several artistic liberties to make the composition effective, including reestablishing harmony through repetition and creating interest with contrast.

From this stage, you can also tell I painted the trees and flowers first, then tucked in the house behind them. This helps to create more of a separation of the foreground from the background. Just make sure the foreground area is dry before applying the background.

emphasizing the focal point

The focal point is the area of your painting where you want your color, light and texture to really shine. To help lead the viewer's eye through the painting and to the focal point, it's important that your composition have:

- **Contrast and a range of values.** To make your light areas stand out, you need dark areas to really make them pop. Without these darks, your subject will run the risk of looking bland.

- **A well-placed focal point.** The Rule of Thirds is probably the easiest way to determine where your focal point should be. Simply imagine or lightly pencil in lines that divide your surface into thirds both horizontally and vertically. According to the Rule of Thirds, anywhere these lines intersect is a good place to position your focal point.

- **A well emphasized focal point.** To really draw the viewer's eyes to the focal point, create your greatest contrast there. You could place your lightest light next to your darkest dark or a color next to its complement or a warm color beside a cool color.

evaluating your composition

Set your painting up so that it can be viewed from a distance. Sometimes just getting some space between you and the painting allows you to assess it more objectively. You can also turn the painting sideways or upside down to see if any areas in your painting need to be strengthened. Ask youself:

- Is the interest area in the right place?

- Is there enough contrast to draw the viewer's eye to the focal point?

- Do other elements in the painting lead your eye into the interest area?

- Is there a sufficient amount of darks to amplify the lights?

- Are the vertical and horizontal placements in the composition used effectively?

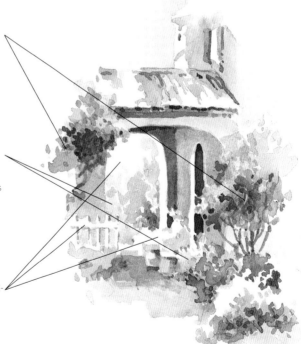

Green leaves next to the red flowers help draw attention to the focal point.

Yellow is the most reflective color, and next to the white of the paper, yellow adds variety to the light areas.

Whites draw the greatest attention to the focal point.

Focusing on the Focal Point
Because the focal point is such an important part of the overall composition, its important that you take the time to plan it's location and how it will be emphasized.

plein air tip

Because the interest area is the most important area in a painting, paint it first when painting on location. You never know when the light may shift or a breeze may blow and alter your subject.

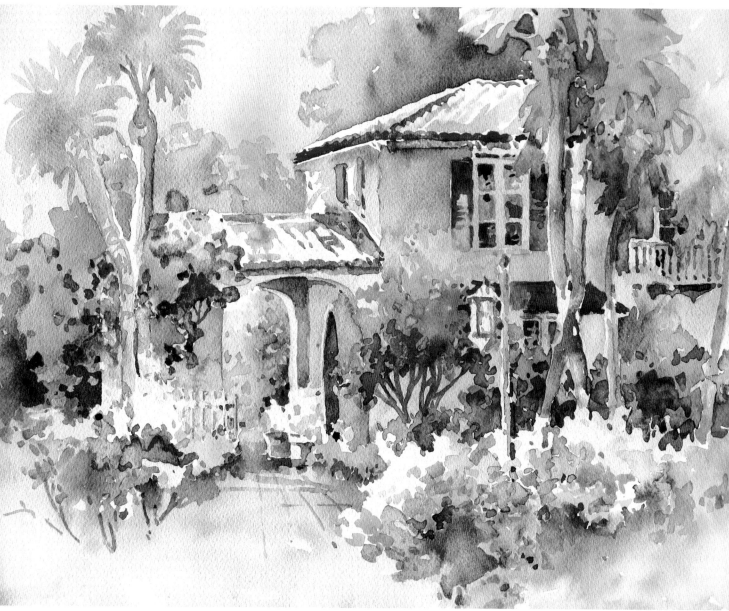

Darks Bring the Lights Forward

The beautiful pure colors of the flowers, the light yellow greens and the whites in this painting take on a three-dimensional effect with the cool blues, greens and violets placed behind them. Remember that cool colors recede and warm colors come toward you. Notice the location of the arch, the painting's focal point. Avoid placing the focal point in the exact middle, on the edges or in the corner of your paper.

SOUTHERN CHARM - 12" × 18" (30cm × 46cm)

create unity and movement with shapes

The way you use shapes in your composition can give your paintings a sense of unity as well as help lead the viewer's eye throughout the painting. When the viewer's eyes are smoothly led through the painting, the viewer will feel satisfied looking at your painting. Here are some ways to create unity and movement with the shapes in your painting:

- **Create variety within shapes.** Pleasing shapes will have a range of edges—some will be soft (or lost), others will be hard (or found); some will be consistent, others irregular. If your shapes are too similar they will become boring for the viewer.

- **Overlap shapes.** This creates a smooth, easy path for the viewer's eye to move around.

- **Repeat shapes.** Shapes that are slightly different from each other are more interesting than those that are exactly the same, but it's important to balance variety with repetition.

- **Vary the color.** There are several ways you can do this—colors can change from light to dark, warm to cool, intense to subdued. These changes also encourage the movement of the eye through the painting.

- **Include changes.** In addition to shape and color, altering the texture, line, direction or value will also lead the viewer's eye. Changes can be abrupt or gradual, though it is generally more pleasing to the viewer if the change is gradual.

a note about backgrounds

You want to create a background that supports the subject matter. Sometimes the only background you need is a dark area that makes your subject really stand out; other times you may need to create something more representational. The important thing to remember is the background should enhance your subject matter, not distract from it.

The Background Ties the Painting Together
The dark shapes unify this painting and lead your eye through the composition. The dark shapes are not solid; they are broken up into a number of other pots and shapes, linking one area to another. The large vessel with the gold design draws the viewer's eyes in, but the repeating rounded vessels in the background and on the right bring out the jewel quality of the foreground vessel by contrast.

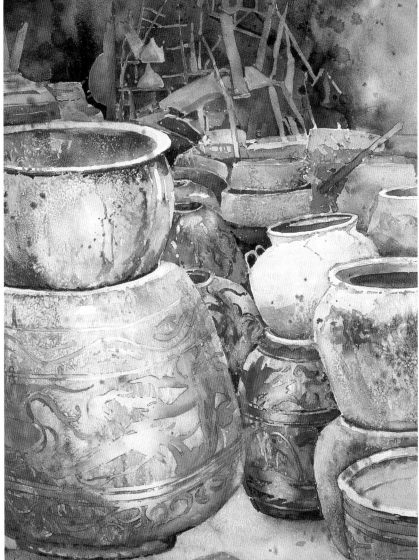

CHINESE PATINA - 30" × 22" (76cm × 56cm)

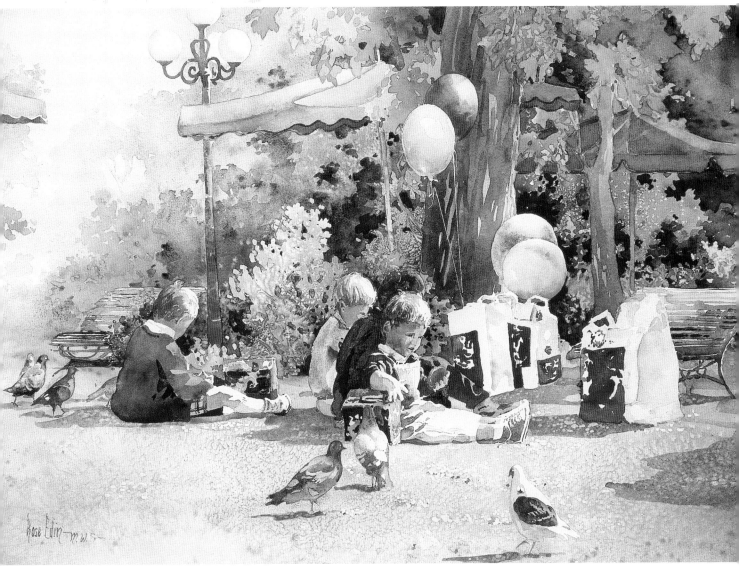

A Shape That Stands Alone

There are a variety of shapes in this painting, yet it's still a harmonious composition. The overlapping shapes of the children, bags, balloons, trees and bushes help draw the eye into and throughout the entire painting. The foreground pigeon is what I call a "throw out" shape, which is not repeated elsewhere in the composition, but acts as an arrow, drawing the viewer's eye to the focal point.

"throw out" shapes

"Throw out" shapes are those shapes that aren't repeated within the composition. As such they stand out and seem to be just thrown into the composition. Because these shapes stand out, they are wonderful tools for directing the viewer's eyes to the center of interest.

static and dynamic compositions

The overall feel of your composition can be either static or dynamic, depending on what you want to convey to the viewer. Static compositions suggest order and tranquility. They suggest structure and stillness. This type of composition emphasizes vertical and horizontal shapes and lines, and feels comfortably contained within the borders of your painting surface.

Dynamic compositions, on the other hand, suggest energy and movement. Rather than lines that are neatly horizontal and vertical, a dynamic composition may be irregular with a zigzagging movement to the overall composition.

The subject before me often determines whether the composition is static or dynamic. Does the subject suggest peace, tranquility and quietness? Is there an interesting diagonal movement or a feeling of excitement and drama within the subject? How I answer these questions determines the type of composition I create.

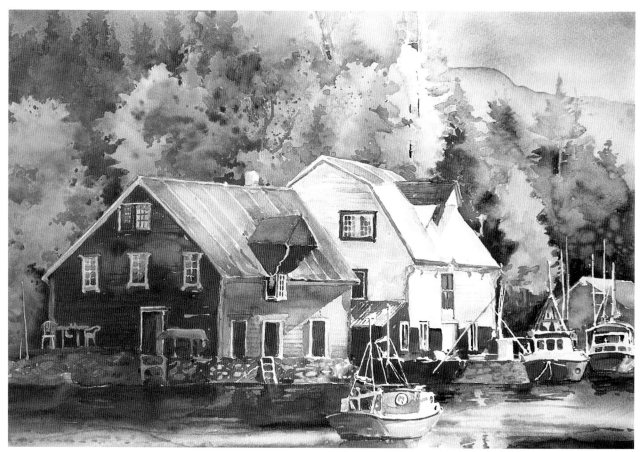

Static Composition
The orderly vertical shapes of the houses, boat masts and trees work together along with the horizontal shapes of the stone wall and water to create a sense of stillness in this painting. The subdued tones of the colors and the indirect light also add to the feeling of tranquility.

THE FAMILY PLACE - 22" × 30" (56cm × 76cm)

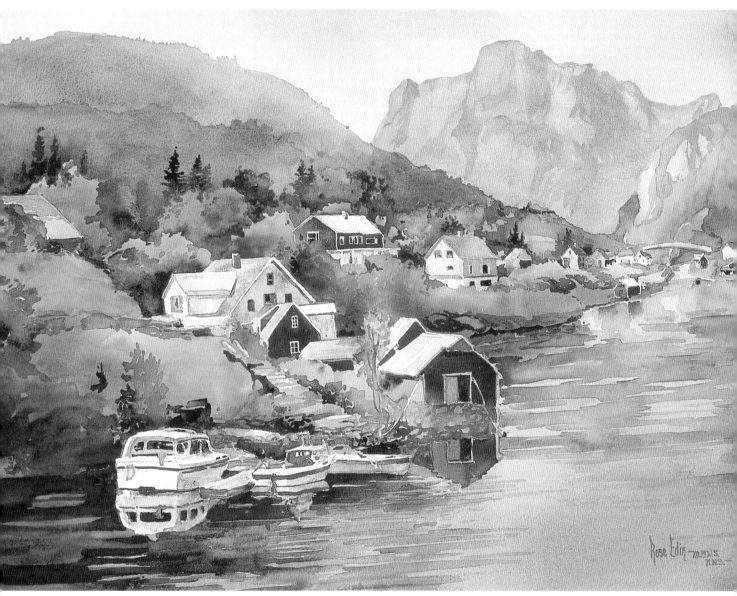

Dynamic Composition

A jagged line is created with the foreground white boat. The line is carried through the houses to the mountains in the background and is echoed by the shoreline. The brighter tones also evoke a feeling of energy and movement.

NORWEGIAN FJORD · 22" × 30" (56cm × 76cm)

composing with values

Remember, value is the relative lightness or darkness of a color. Changes in an object's value help suggest its form. Value changes also indicate the direction of light. A successful painting should have a range of values; that is, some lights, midtones and darks should be present in your composition. Doing a value sketch is a common way to work out the values in your painting, as it allows you to determine where the lights and darks will be in your composition.

Using Blue Instead of Black

Tube black is such a dull, lifeless color. Instead of doing a black-and-white value painting, I prefer to use Cobalt Blue because it's permanent, transparent and can be washed off the paper if necessary. Cobalt Blue also has staying power—it does not lift off when another color is layered over it. In fact, it creates a beautiful base over which to layer other colors. (See pages 82–83 for more about layering color over Cobalt Blue.)

value and color

You can create a range of values with each color; however, each color does not have the same value range. Your darkest yellow will never be as dark as your darkest red, and your darkest red will never be as dark as your darkest blue. Creating a value scale of each color on your palette will help you familiarize yourself with each color's value range.

More Water Creates a Lighter Value
One of the benefits of watercolor is that you simply add more water to lighten a color's value.

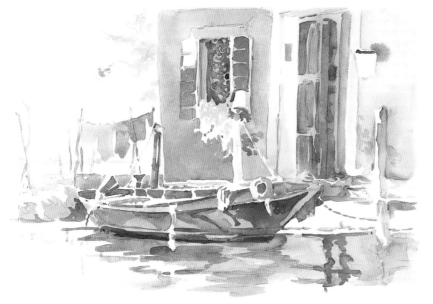

Painting Values in Blue
When working on location, consider a blue value sketch. After applying your light and middle tones, let the painting dry before applying the dark values.

Inanimate subjects, such as buildings and boats, are given dimension with a blue underpainting. It can also be used in shadow areas of people. Blue simplifies the color as you lay other colors over it. Other blues may also work well, such as Cerulean Blue and Antwerp Blue. The only time I do not use blue value studies is in floral paintings.

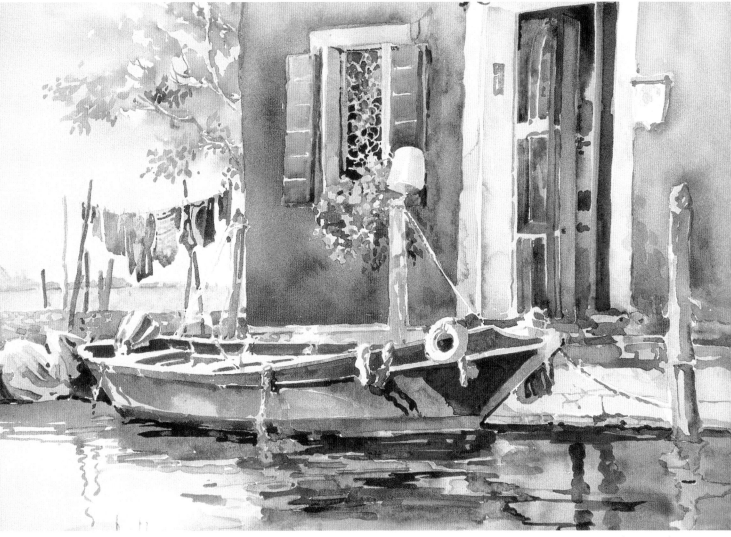

Middle Values Unify

The red-orange building in this painting is a great backdrop for the blue boat. Although the red house was in shadow, the sun hit the boat directly, making it the perfect focal point. Notice that the blue shadows added to the building in the underpainting show through the red orange layer.

BURANO - 18" × 24" (46cm × 61cm)

tip for painting en plein air

Shadows and light move very quickly when you are painting on location. Use Cobalt Blue to quickly establish the painting's values.

conveying mood

One of the best ways to establish the mood of the scene is to use a value scheme that is either high key or low key. A high-key value scheme uses light values, and because of the dominance of lighter shades, darker areas really pop and should be used carefully. High-key value schemes are generally used to suggest a mood that is light and cheerful. The reverse is true for low-key value schemes. Low-key paintings consist of darker values, making the lighter passages of your painting really stand out. They tend to suggest a mood that is more somber, even mysterious.

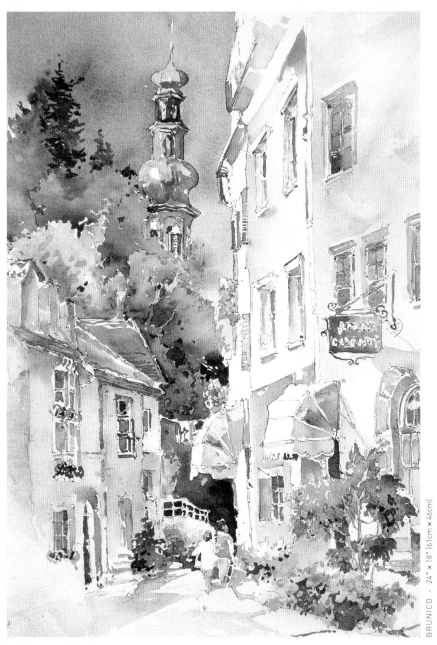

BRUNICO - 24" × 18" (61cm × 46cm)

High-Key Value Scheme
The sun is shining, bathing this entire scene with light and giving it a high key. A slight shadow is cast upon the buildings to the left, indicating the direction of the sun. Note that the dark trees behind the buildings really bring out the golden tones of the building on the right.

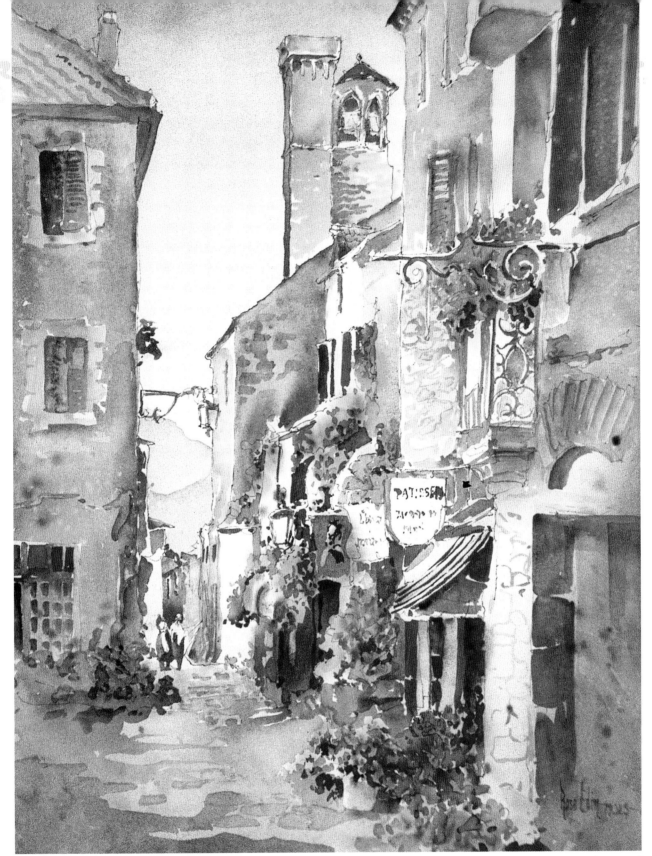

Low-Key Value Scheme
It was a cold, cloudy day, making this street scene much darker than it would have been on a brighter day. I used a darker shade of blue for the underpainting and applied additional layers of pigment over it to create the darkest areas.

CORDES – 24" × 18" (61cm × 46cm)

combining photographs

Sometimes elements of two reference photographs can be put together to form an interesting composition. When that happens, you need to be able to combine the two. Here's how:

One Composition, Two Images

1 With a pair of scissors or a craft knife, cut out the areas you wish to use from the photographs.

2 Reassemble the images into a pleasant composition. Since you can move the images around, you can experiment to see what arrangement looks best.

3 Glue the images to a piece of white paper in the arrangement you prefer.

4 Make a black-and-white copy of the new composition. This will make the image look more cohesive, and it will show you where the lights and darks are.

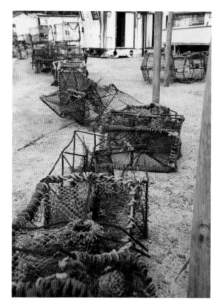

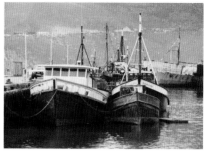

Reference Photos
These colorful lobster crates caught my eye. Over to the right, the boats were moored. I felt the crates would create an interesting path to the boats. On the photocopier the subject can be enlarged or decreased in size.

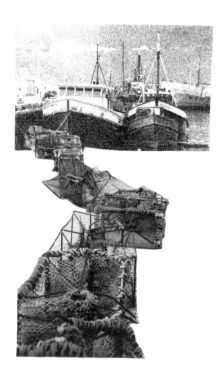

Black-and-White Photocopy
Once the combined images are copied, they appear as a seamless whole.

Sketching Out the Transition Area Can Help
In this pen sketch, I've worked out how the areas where the boats meet the lobster crates come together. Not only did I carve out areas for the crates, but I also suggested where the boats' reflections in the water areas would occur. I also took some artistic liberties with the boats' arrangement. Taking the time to work this out beforehand is always preferable to working it out in your final painting.

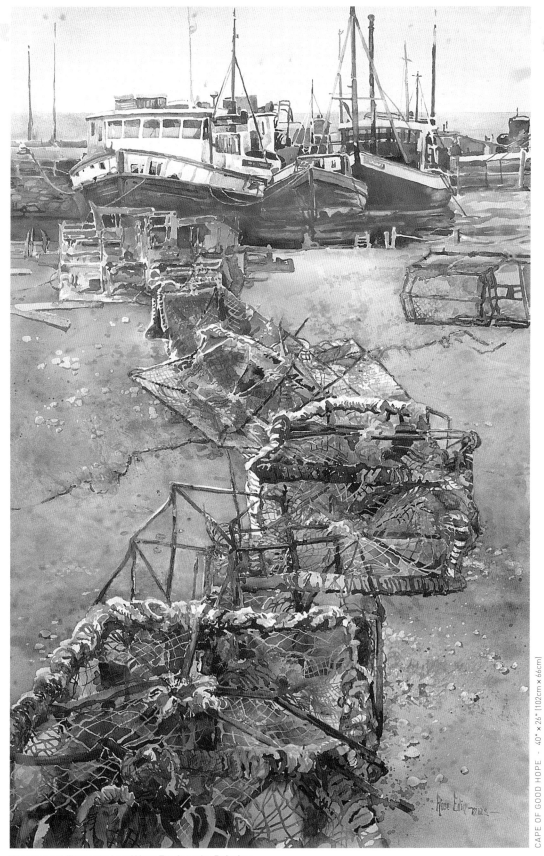

CAPE OF GOOD HOPE - 40" × 26" (102cm × 66cm)

Foreground Elements Lead Your Eye Into the Painting

eliminating unnecessary details

With the drawing shortcuts we have discussed, you can draw anything. Remember to eliminate any details that don't serve your composition well. Reference photos often capture more detail than you'll need. Just because something appears in your photograph doesn't mean you have to include it in your composition. Simply cut out any details you don't need and combine the edited photograph with other reference photographs.

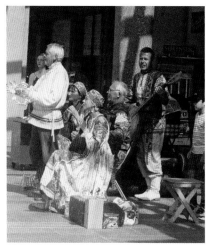

photo 1

photo 2

Reference Photos
While walking down a street in Bergen, Norway, we came upon this little Russian group playing beautiful music. The bright sunlight hitting the figures presented a wonderful challenge to preserve the white of the paper as well as use some beautiful color.

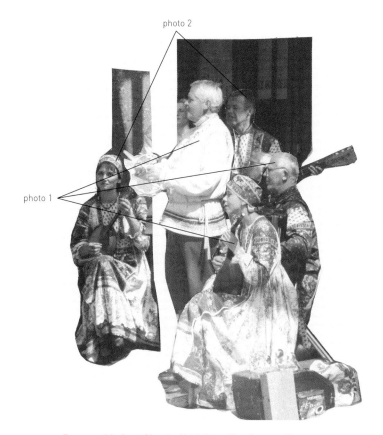

photo 2

photo 1

Reassemble for a Simple, Yet Interesting Composition
As you can see in this photocopy, I combined aspects of both reference photos and re-positioned them for a stronger composition.

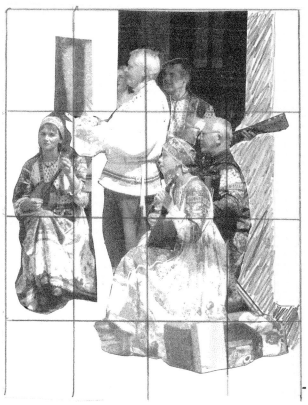

Pencil In Any Details
I extended the background to further strengthen the composition, then added the grid to make the subject easier to draw.

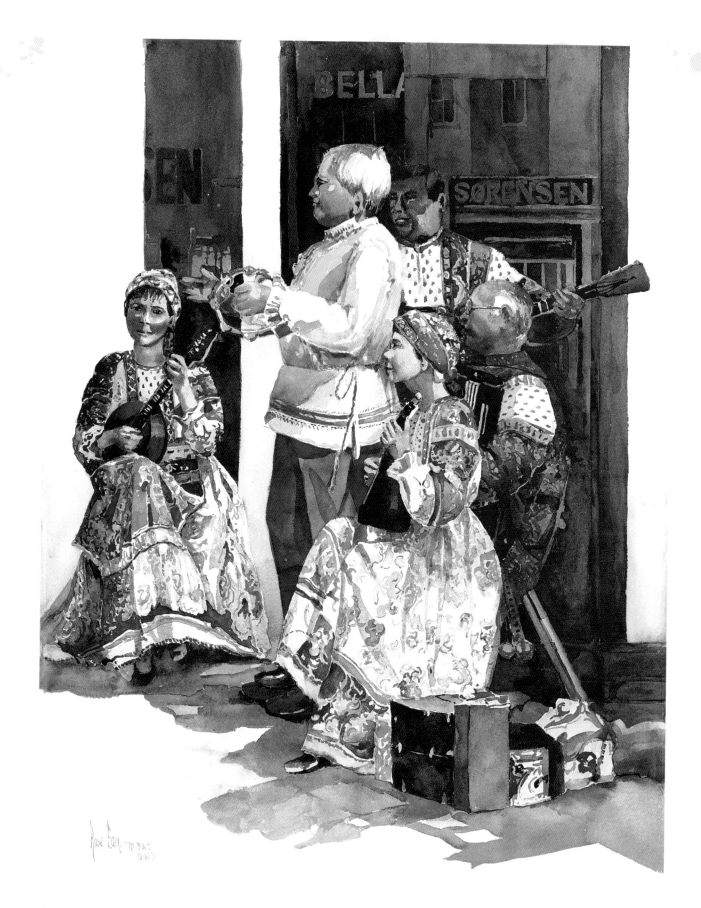

Dark Verticals With Minimal Detail

altering photographs

These African women were seated by the side of the road painting some extraordinary works of art. When I looked back at these reference photos in preparation for this painting, I had to decide how to lead the viewer's eyes up to the figures from the foreground. This seemingly impossible task became quite easy once I decided to eliminate some of the unnecessary details.

The challenge was to design a photograph with multiple elements in a dynamic way. Overlap the objects and think of how to arrange the shapes to lead the eye up to the center of interest.

materials list

PIGMENTS
Antwerp Blue, Burnt Sienna, Cadmium Orange, Cerulean Blue, Cobalt Blue, Cobalt Green, Permanent Magenta, Quinacridone Gold, Scarlet Lake, Winsor Yellow

SURFACE
300-lb. (640gsm) cold-pressed watercolor paper

BRUSHES
2-inch (51mm) hake, no. 4 rigger, no. 16 or 18 round

OTHER
Eraser, masking fluid, paper towels, pencil, rubber cement pickup, ruler, scissors, spray bottle filled with clean water

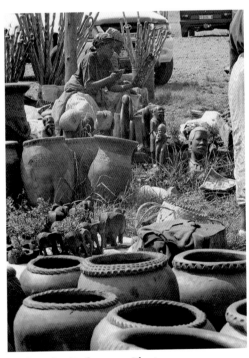

1 Examine the Reference Photo
Carefully study the photograph to decide which elements to leave out and which to alter. I decided to move the figures closer to the foreground and make them larger. I also decided to minimize the grass between the pots and figures, move the elephants up and farther to the right, and move the larger figurine on the right to create a visual path to the center of interest.

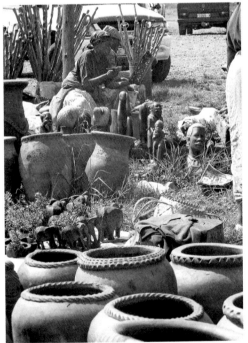

2 Make a Black-and-White Photocopy
Photocopy the photograph to get a sense of the values in the piece. Enlarge the upper half of the painting and the elephant carvings about ten percent and make another copy.

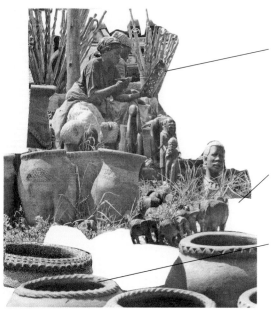

Enlarged the upper half of the painting

The bottom half of the painting overlaps the upper part

Reduced the number of foreground pots

3 Cut and Rearrange

Cut out the elements you wish to include in the painting. Move elements around until you are pleased with the look, then glue them to a piece of white paper. Make a photocopy of the entire composition.

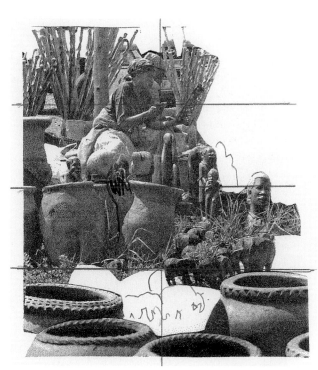

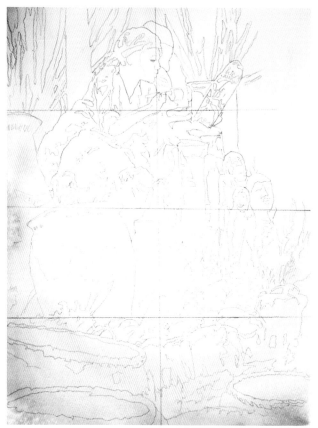

4 Enlarge the Image and Add Important Details

Make another black-and-white photocopy of your composition and enlarge the composition proportionately. For instance, an 8" × 10" (20cm × 25cm) paper can be enlarged to a 16" × 20" (41cm × 51cm).

5 Sketch the Subject and Apply an Underpainting

Create a similar grid on your watercolor paper, then sketch the composition using the photocopy as your guide. Erase the grid lines once your sketch is complete.

Add water to Winsor Yellow, Scarlet Lake and Cobalt Blue, and mix until the colors are the consistency of cream. With your 2-inch (51mm) hake, thoroughly wet the paper with clean water, avoiding the upper right and center of the paper. Apply the yellow, red and blue as illustrated on page 22. Tip the paper until all the colors run together. creating a soft background.

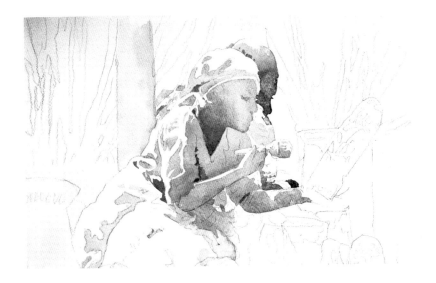

6 Add Shadows to the Figures

Using diluted Cobalt Blue and your no. 16 or 18 round, create the shadows and dark values on the women's faces, headscarves and clothing as well as the pole behind them. Let this dry, then apply a second application of Cobalt Blue for the darkest shadows and values. Let this dry.

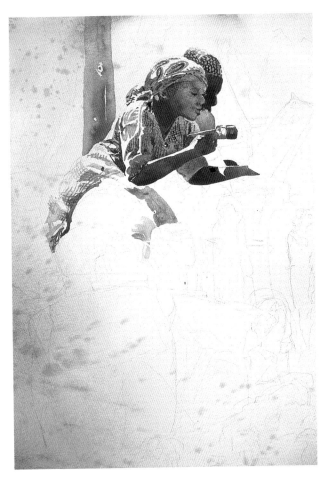

7 Refine the Women's Skin and Clothing

Using your no. 16 or 18 round, apply Permanent Magenta to paint the face of the distant woman, amplifing the woman in front. Apply Cadmium Orange, Scarlet Lake and Permanent Magenta next to each other on the head and arms of the woman in front, letting the colors mingle on the paper.

Use Antwerp Blue for the headscarf on the woman in the background, and use Winsor Yellow, Cadmium Orange and Scarlet Lake for the pattern of the headscarf of the woman in front, leaving the lightest light the white of the paper.

Using the same process you used on their faces and headscarves, apply Cobalt Blue with a no. 16 or 18 round over the shadows and darkest values of the foreground woman's blouse and arms, and let this dry. Clean the brush, then apply Cerulean Blue to the shadows in the sunlit areas of her dress. Apply the pattern on the woman's blouse with Scarlet Lake. Apply Cobalt Blue to the shadow area in her lap (don't get too detailed here). Apply Winsor Yellow and Cadmium Orange to the background woman's clothing.

begin with the center of interest

By doing the interest area first I often receive inspiration for the rest of the painting. At this point anything can be fixed. If the underpainting is too dark or messy it can be washed off with Mr. Clean. If the drawing is inaccurate, let the painting dry thoroughly, erase and redraw the image.

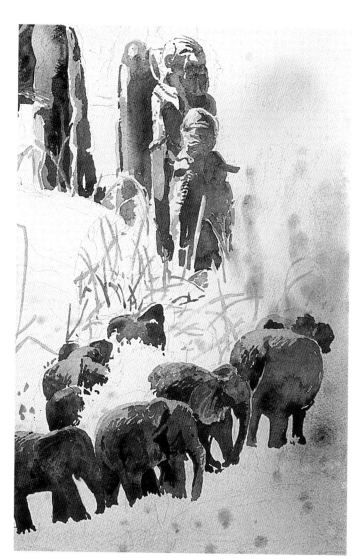

8 Refine the Figurines

Apply Cobalt Blue with a no. 16 or 18 round to the shadows and dark values of the elephants and figurines on the right side of the painting and let dry. Since the elephants are made of an ebony wood, they should be slightly warmer than the figurines made of stone, so apply diluted Quinacridone Gold next to diluted Scarlet Lake over the Cobalt Blue shadows. On the stone figurines, apply diluted Scarlet Lake next to Permanent Magenta. Let the colors mix and mingle to create rich and varied gray tones.

Paint some of the foreground grasses with Winsor Yellow and Quinacridone Gold.

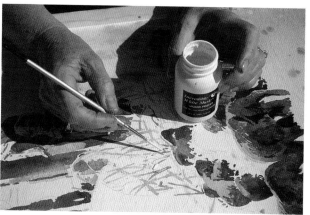

9 Apply Masking Fluid

Use the no. 4 rigger to apply masking fluid to the grass blades, the elephants and the highlights of the pots. Be precise and fill in all the holes where the paper is showing through in your painted areas. Wash and soap your brush occasionally, and be sure all the light areas, such as the sticks, figures and grasses, are masked. Let the masking fluid dry.

apply masking fluid with care

Masking fluid saves the whites to create the effect of glowing lights or to preserve fine lines. Use care when applying the masking fluid. It can create a hard edge that becomes obvious in the wrong place of a composition.

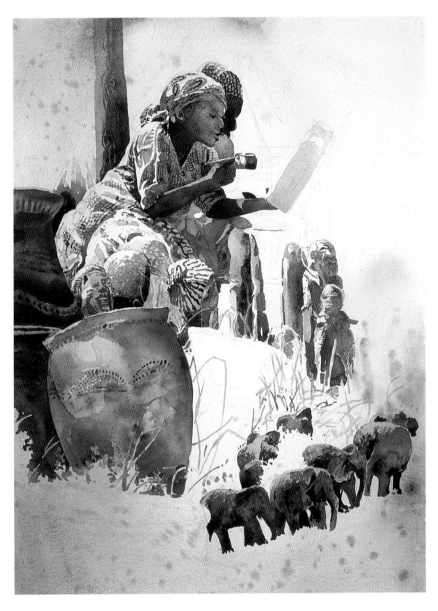

10 Finish the Women and Paint the Pots

Apply a layer of Cobalt Blue to create shadows on the pots and the woman in front with a no. 16 or 18 round and let dry. For the light pot toward the center, apply Winsor Yellow, Cadmium Orange and Scarlet Lake side by side, and let them mingle into each other. On the darker pots, apply Permanent Magenta, Burnt Sienna and Scarlet Lake next to each other, letting them mingle together on the paper.

Finish the foreground woman's skirt by applying Cerulean Blue to create the checkered pattern. Add a bit of green behind the figures to see how the lightest areas stand out against the darkest areas (you can always remove this with the magic eraser). To make the green, apply Winsor Yellow, Quinacridone Gold and Antwerp Blue next to each other. Let this dry overnight.

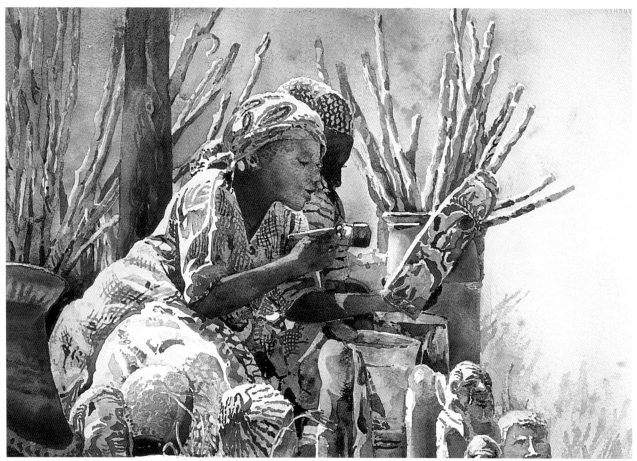

11 Refine the Upper Portion of the Painting

Paint the additional pots surrounding the women using the techniques for the pots in shadow in step 10.

Complete the figurines using the techniques in step 8.

Paint the background sticks with Cobalt Blue in the shadow areas. Let this dry, then finish the sticks with Quinacridone Gold for the light areas and Scarlet Lake for the shadows. Let this dry.

Apply masking fluid to the sticks, the post, the tops of the pots surrounding the women and the upper half of the figurines with the no. 4 rigger. Let the masking fluid dry completely.

With your 2-inch (51mm) hake, wet the entire paper with clean water. Using your no. 16 or 18 round, apply creamy Winsor Yellow in the right-hand areas of the wet paper; as you move left, switch to Quinacridone Gold, then Antwerp Blue. Rewet the paper with your spray bottle as necessary. Tip the paper and let these two colors run together, creating a mixed green, and spatter some of these colors for variety.

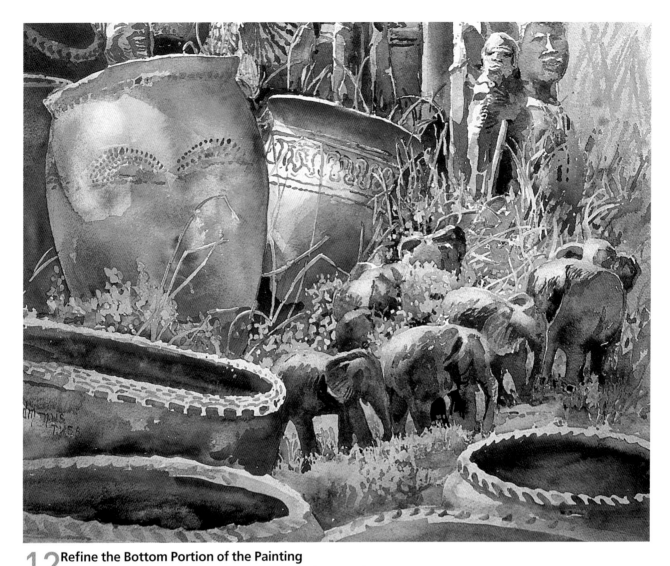

12 Refine the Bottom Portion of the Painting

With a no. 16 or 18 round, apply Cobalt Blue to the foreground pots, applying a second layer of Cobalt Blue as necessary for the darkest shadows. As you apply the blue, break up the overall shape of these foreground pots. Refine the foreground pots with Cadmium Orange, Scarlet Lake and Permanent Magenta, mingling the colors as you did for the pots in shadow in step 10. Paint the shadows of the center pot with Cobalt Blue. Let this dry, then complete the center pot by applying Winsor Yellow next to the highlight, then Cadmium Orange, then Scarlet Lake. Allow these colors to mingle together on the paper and then let dry.

Using the no. 4 rigger, mask the pots and elephants and let this dry. Behind the masked grass blades, apply Quinacridone Gold and Cobalt Green in select areas. Let this dry.

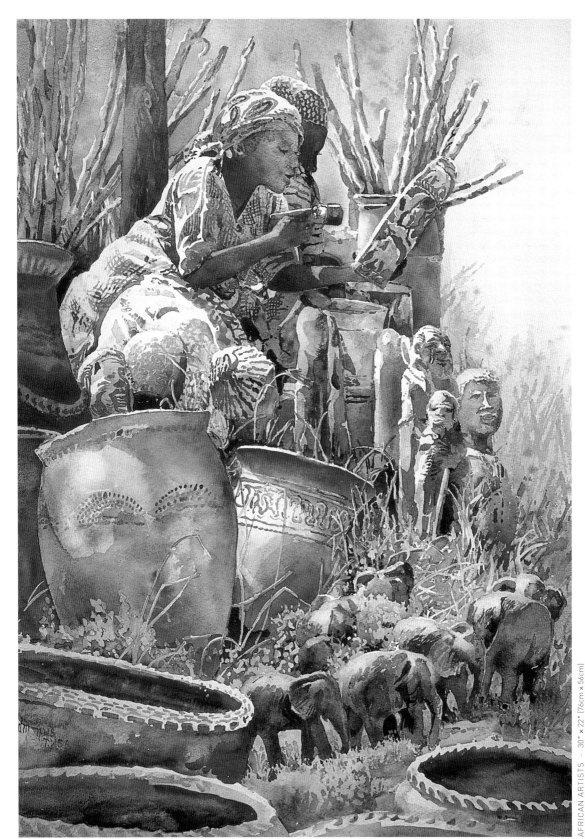

AFRICAN ARTISTS · 30" × 22" (76cm × 56cm)

13 Add the Final Touches

Remove all the masking fluid with a rubber cement pickup and make any adjustments necessary.

Notice the dynamic movement of the piece. The lights on the back of the figures, the pots and the elephants create a natural diagonal line, while the counter movement is created by the pots.

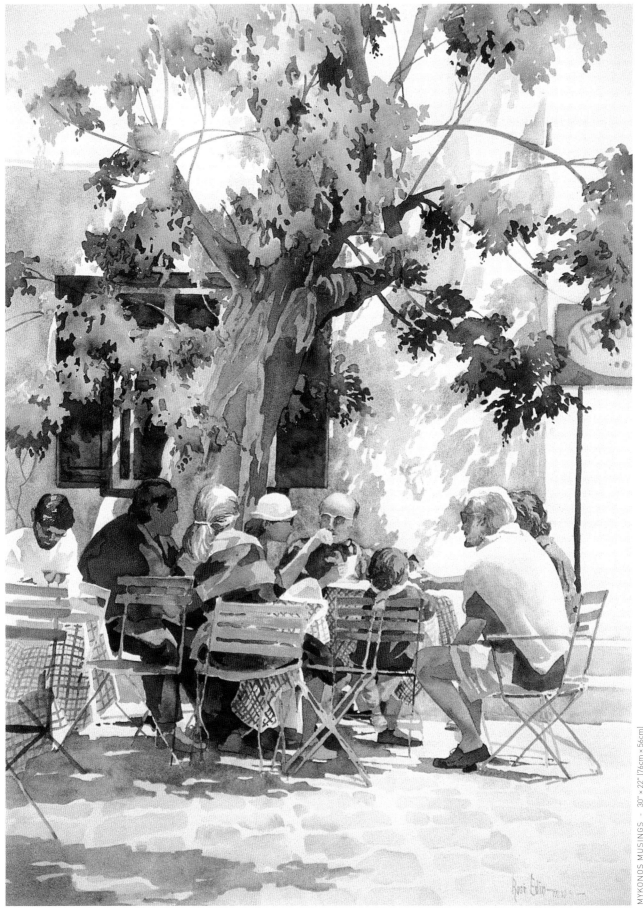

MYKONOS MUSINGS - 30" × 22" (76cm × 56cm)

creating harmony with color

Beautiful color is what always draws my eyes to a painting. For brilliant, spontaneous-looking color, I recommend applying colors next to each other and allowing them to mix and mingle on the paper, rather than mixing the colors ahead of time on the palette. I also like to use pure colors from the tube that haven't been mixed, so it's important to clean the brush well before switching to another color. These are some of the color tricks you will learn in this chapter.

After I drew the composition for *Mykonos Musings*, I used warm analogous colors on the figures and cool analogous colors in the background. You'll learn how to create this harmonious effect in your own work in the pages that follow.

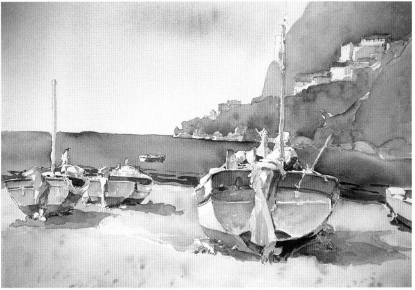

PORTUGUESE BOATS · 18" × 24" (46cm × 61cm)

know your palette

I paint by using mostly pure transparent pigments. Transparent paint allows the white of the paper or the color underneath to show through. I do very little mixing on the palette. Either I layer the color after the painting is completely dry, or I let the wet pigments mingle together on the paper. The result is luminous, beautiful color.

If you look at the colors on this page, you'll notice I use a warm and cool version of each color. This allows me to mix a large range of colors.

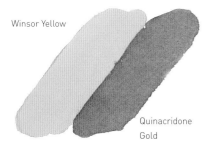

Winsor Yellow

Quinacridone Gold

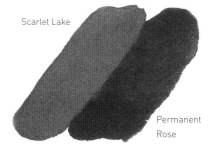

Scarlet Lake

Permanent Rose

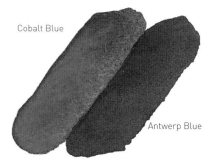

Cobalt Blue

Antwerp Blue

Yellow Family
Winsor Yellow is a cool light yellow that's great for underpainting, while Quinacridone Gold is a very warm, golden color that makes beautiful mixed greens when combined with blue.

Red Family
Scarlet Lake is a warm red that can take on an opaque quality if applied too heavily. Permanent Rose is a cool transparent rose that creates a lovely warm glow.

Blue Family
Cobalt Blue is a great color for underpainting, layering or mixing with other colors. Antwerp Blue, a deep blue with a bit of green in it, produces great dark values when used alone or mixed with other colors.

1

Creating Lively Darks
I never use black in my palette. The closest color to it is Indigo, which can become very opaque if applied thickly. I've found creating a mixed dark is a much more vibrant way to create dark passages. My favorite mixed darks:

1 Antwerp Blue mixed with Permanent Rose

2 Cobalt Blue mixed with Scarlet Lake

3 Cobalt Blue mixed with Quinacridone Gold

2

3

other colors on my palette

Beyond the six colors I always include on my palette, I often expand my palette selection with semitransparent and opaque colors. I also like to use granulating pigments, which means the colors separate, creating a mottled appearance. The different levels of transparency and granulation offer wonderful contrasts to the transparent nongranulating pigments in my standard palette.

The pigments on this page can be made more transparent if diluted with enough water. I often apply these colors over other colors or when using the gauze technique on page 28. These pigments really settle into the gauze fibers to create an interesting effect.

Cadmium Orange
A great color to use with the warm colors on my palette and looks wonderful when applied over an underpainting of Cobalt Blue.

Cobalt Green
This is the only green on my palette and I rarely use it. A painting using a lot of greens is given more life with this color, so long as it's used sparingly.

Cerulean Blue
A beautiful light blue that can act as a transparent color when mixed with a lot of water. Also a good pigment to spatter or use with gauze.

Cobalt Violet
This is a wonderfully subtle violet. I often use this color as a glaze over warm colors.

always arrange your palette the same way

I lay out my palette the same way each time I paint so I can quickly find the color I need. I arrange the pigments in this order: Winsor Yellow, Cadmium Orange, Quinacridone Gold, Scarlet Lake, Permanent Rose, Permanent Magenta, Cobalt Violet, Cobalt Green, Cerulean Blue, Cobalt Blue, Antwerp Blue, Burnt Sienna and Indigo.

Permanent Magenta
A deep maroon that is especially good for creating very dark, transparent areas. Mixed with Cobalt Blue or Antwerp Blue, it creates beautiful mixed darks.

Burnt Sienna
A deep, transparent rust color. Because of its granulations, it's a good pigment to use when painting wood or rocks.

Indigo
The darkest pigment on my palette. Use this color with caution as it can become very dark. I use it in small doses in very dark areas.

the color wheel

Being familiar with the color wheel will unlock the color mixing possibilities of the pigments on your palette as well as help you determine the overall color scheme of your compositions.

At the heart of any color wheel are the three primary colors of red, yellow and blue. These three pigments cannot be mixed or formed by a combination of other colors. You can, however, combine the primaries to create the secondary colors of orange, green and violet. You can also mix a primary and its neighboring secondary color to create tertiary colors including red-orange, orange-yellow, yellow-green and so on. Because I let the colors mingle on the paper, I rarely mix tertiary colors.

Color Temperature

It's important to note that color temperature is relative—some reds appear cooler than others when placed next to each other; however, both will seem warm compared to a cool color like blue. Generally speaking, reds, yellows and oranges are thought to have a warm color temperature and greens, blues and violets have a cool color temperature.

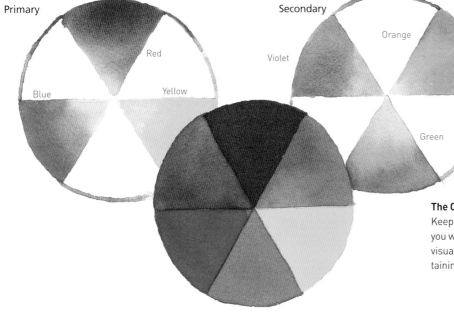

Primary
Red
Blue
Yellow

Secondary
Orange
Violet
Green

The Color Wheel Is a Valuable Tool
Keep a copy of the color wheel with you as you work. It is perhaps the most important visual tool you have for creating and maintaining color harmony in your paintings.

Warm Colors
The color temperature of yellow, orange and red is warm, and the colors advance toward you in a painting, so using them in your interest area may be a good idea.

Cool Colors
The temperature of green, blue and violet is cool. They recede away from you.

color complements

Complementary colors are the opposite colors on the color wheel. They do two important things:

1 They enhance each other when placed next to one another. A green leaf will visually magnify a pink or red flower. The warm color of pink will look closer to you than the cool color of green, suggesting depth and dimension.

2 They create gray when mixed together. The amount of the comple- mentary pigments used determines how gray the color will be.

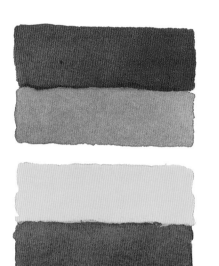

Primary Colors and Their Complements
When placed next to each other, color complements add to the intensity of the other color. The colors seem to vibrate, which gives an extra punch to the area where they're applied.

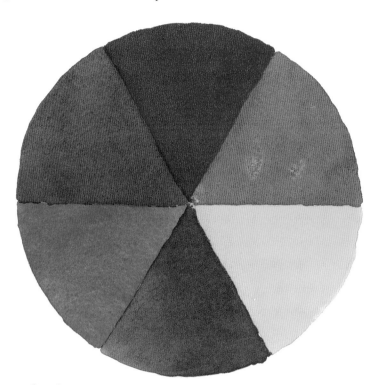

Complementary Color Makeup
When you look at the color wheel, you'll notice that each set of complementary colors consists of one primary and one second- ary color, which means that, in a sense, all three primary colors are present in each set since secondary colors consist of two primary colors.

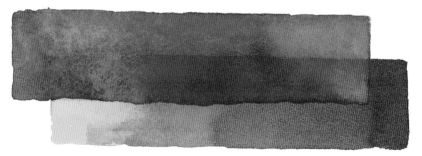

Mixing Neutrals From Color Complements
Maintain the harmony of your color palette by creating neutral shades mixed with opposite colors on the color wheel. These mixed hues will enhance and not distract from your overall color scheme.

color harmonies with analogous colors

Analogous colors sit next to each other on the color wheel. Think of them as a family; since they're closely related to each other, they create a harmonious yet interesting visual effect.

When selecting color harmonies, first choose a dominant color. The colors on either side of that dominant color will form the analogous color harmonies. The lighter analogous color can be used for light areas, and the darker analogous color can be used for the shadows. For instance, if you are painting a rose, you might select a red as the main color. This means you'll use an orange for the lighter areas and a violet in the shadows.

| blue, violet and red | violet, red and orange | red, orange and yellow | orange, yellow and green | yellow, green and blue | green, blue and violet |

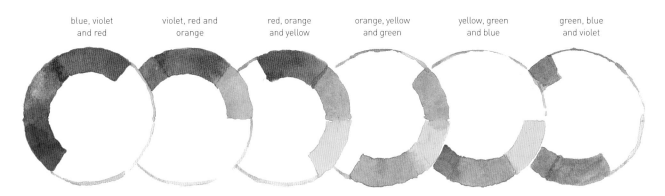

Analogous Colors
Any color on the color wheel along with the colors on both sides of it can be used to create a harmonious color scheme.

Local Color vs. Color Harmonies
Consider an object's local color when determining the dominant color of your analogous color scheme. (An easy way to remember local color is to think of it as the actual color of an object.) The local color of a pine tree may be green, but to simply paint the tree a flat shade of green doesn't create much excitement for the viewer. However, if you incorporate blue and yellow, green's analogous colors, your tree painting becomes much more interesting.

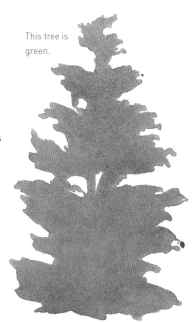

This tree is green.

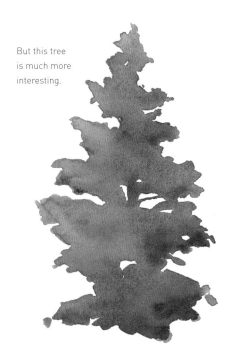

But this tree is much more interesting.

creating color harmony

When colors are visually separated on the painting surface, it heightens the appearance of light and creates a sense of order and balance in the visual experience. This type of painting also engages the viewer's eyes, and fuses the colors together forming a three-dimensional object. In this way, the viewer becomes involved in the creative process.

Using Analogous Colors

When determining which analogous color scheme to use, I use the object's local color as the main color and build the analogous color scheme around that. Working from a reference photograph or on location is a quick and easy way to make that decision.

the key to creating color harmony is often imagination

Using analogous colors to create color harmony is simply a way of breaking up the color and creating excitement in your painting. Remember, as with the Impressionists, the goal is not to create a photorealistic image, but rather to use pure color in a way that entices the viewer.

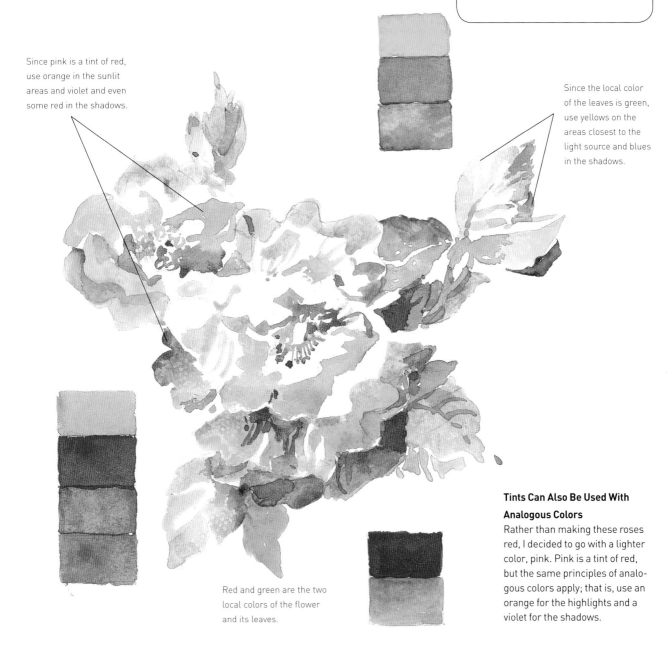

Since pink is a tint of red, use orange in the sunlit areas and violet and even some red in the shadows.

Since the local color of the leaves is green, use yellows on the areas closest to the light source and blues in the shadows.

Red and green are the two local colors of the flower and its leaves.

Tints Can Also Be Used With Analogous Colors

Rather than making these roses red, I decided to go with a lighter color, pink. Pink is a tint of red, but the same principles of analogous colors apply; that is, use an orange for the highlights and a violet for the shadows.

mingling tones for vibrant color

Allowing the pigments to mingle together on the paper creates lively color passages that intrigue the viewer's eyes. Simply apply the colors side by side on your paper and allow them to move and mix together on their own. Sometimes you may have to help the colors along by tilting your surface. As you get comfortable with mingling, you discover you can create exciting areas of color instead of flat passages with little interest for the viewer.

Tips for Mingling

- **Create the right consistency.** In order to mingle properly, the pigments should have a juicy consistency. Make sure you've added enough water.

- **Apply one color at a time.** For the cleanest, purest mingled tones, clean your brush before picking up another color from your palette.

- **Practice makes perfect.** Familiarize yourself with the colors on your palette and with the mingling process before you try this on a painting. Practice will minimize any unwanted surprises.

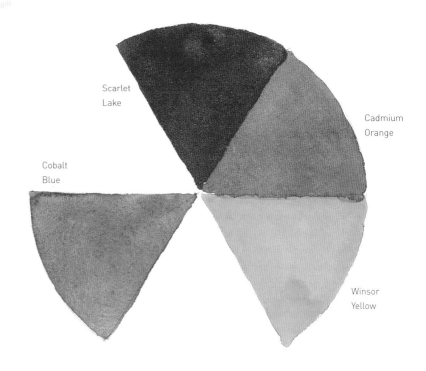

Non-Mingled Flat Colors
Although these are bright tube colors, they are not as eye-catching as the mingled colors below.

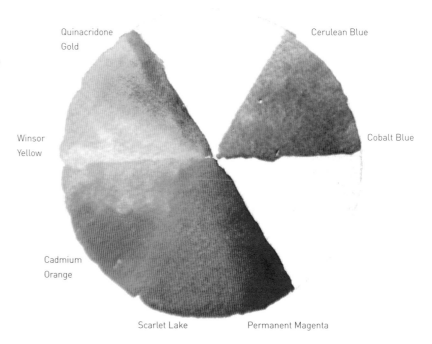

Eye-Catching Mingled Color
By mingling the colors, you achieve much more interesting tones as colors mix together on the paper, creating interesting yet harmonious blends of pigment.

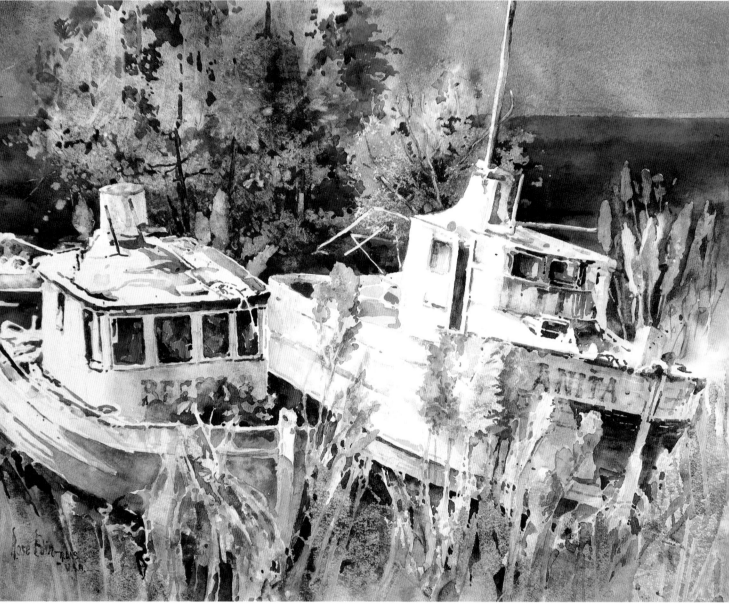

Mingled Colors in Action
The white boats are a natural center of interest as they nestle among the huge plumes in this California seaside scene. The mingled colors of the grasses, trees and water create a vibrant contrast to the boats.

BEACHED - 22" × 30" (56cm × 76cm)

color temperature and color harmonies

A color's temperature can be used to send a message to the viewer. Want to convey a feeling of energy and excitement? Use warm colors. If a cool, serene scene is what you're after, use cool colors. By having one color temperature dominate the painting, you keep your message consistent. Contrast the painting's overall color temperature in the areas you want to emphasize, such as the center of interest.

Cool Colors Appear to Recede
I mostly used blues, greens and violets in this painting, giving it a cool undertone. I saved the reds for the areas I wanted to emphasize, such as the buildings that lead your eyes to the Great Wall.

Warm Colors for the Great Wall and Buildings
For the warm areas I used Winsor Yellow, Scarlet Lake and Permanent Rose.

Cool Colors Are Used on the Hills
For these cool areas I used Cobalt Blue and a mixed green created with Antwerp Blue and Quinacridone Gold.

Cool Colors Make the Warm Colors Pop
The trees and hills set off the interest area and contain the colors Permanent Magenta, Cobalt Blue and a mixed green created with Cobalt Blue and Quinacridone Gold.

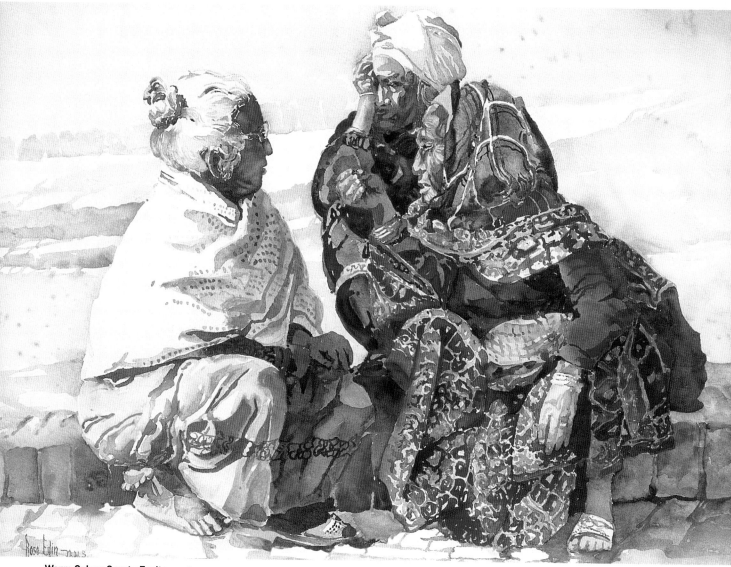

Warm Colors Create Excitement

These Nepalese women were having an intense conversation in their village square, so I used warm tones to create that sense of excitement and to reflect the heat of the day.

THE TALKER AND THE THINKER - 22" × 30" (56cm × 76cm)

create harmonious grays

It's important to have some quiet, muted grays in your composition to give the viewer's eyes a place to rest, as too many intense, vibrant colors can be over-whelming. Gray tones can also make other colors look even more vibrant in comparison.

Remember that mixing two comple-mentary colors will create a gray, as will combining all three primary colors. You can control the temperature and the value of the gray you create by adjust-ing the ratio of the colors used and the amount of water you add to it.

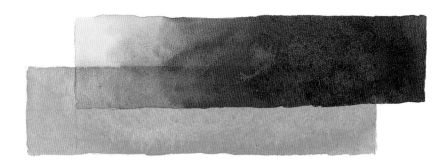

Layering Warm Colors Over Blue
One of my favorite ways to create lively grays is to layer warm colors over a blue base. These dark tones still appear vibrant, but can be softened by using pigments diluted more with water.

Yellow and Violet Mixed Grays

Winsor Yellow Cobalt Violet

Blue and Orange Mixed Grays

Cadmium Orange Cobalt Blue

Red and Green Mixed Grays

Scarlet Lake Mixed green (Quinacridone Gold + Cobalt Blue)

SANTORINI – 24" × 18" (61cm × 46cm)

Lively Grays

The volcanic island of Santorini, Greece, is filled with towns full of white buildings with blue domes. This presents the challenge of suggesting depth and form on a white painting. Here, the buildings' shadows are not gray. They reflect the blue of the sea and sky together with the sunlight. The overhead sun creates a unique pattern of white, which is linked throughout the painting.

Instead of using Cadmium Orange in this painting, I used the transparent pigments of Scarlet Lake and Winsor Yellow, which add to the sense of light.

deepen values by layering

One of the wonderful things about working with transparent watercolors is that you can darken a color or create vibrant new ones by simply layering one color over another. Layering is a great way to play up or tone down an area.

Tips on Layering

- **Let the surface dry.** Perhaps the most important part of layering is to make sure your surface is completely dry before applying the next color. If you layer too soon, you'll end up mixing the colors on the paper.

- **Build up color.** Until you become comfortable with the pigments on your palette and the process of layering, build color slowly until you get the effect you desire. If the colors are applied too heavily, you'll cover the color underneath completely. It's much easier to build layers than it is to scrub the color away and start over.

- **Test color combinations.** Try out different layering combinations on a scrap of paper. It's a good way to hone your layering technique as well as avoid unwanted surprises. Maintain a list of the combinations you particularly like.

Winsor Yellow over Cobalt Blue

Cobalt Green over Cobalt Blue

Antwerp Blue over Cobalt Blue

Cerulean Blue over Cobalt Blue

Cobalt Violet over Cobalt Blue

Permanent Magenta over Cobalt Blue

Indigo over Cobalt Blue

Burnt Sienna over Cobalt Blue

Quinacridone Gold over Cobalt Blue

Cadmium Orange over Cobalt Blue

Scarlet Lake over Cobalt Blue

Permanent Rose over Cobalt Blue

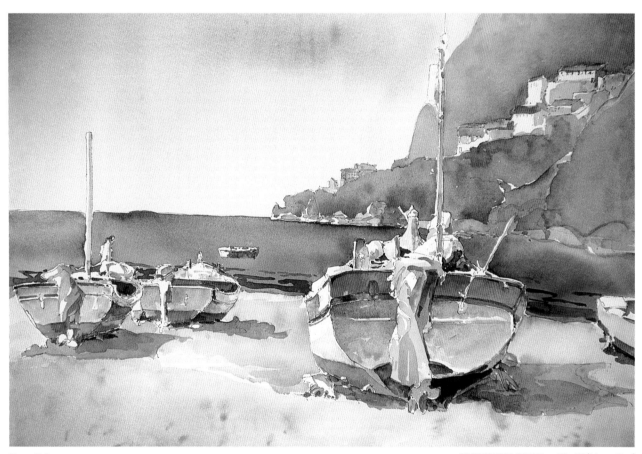

Deep Values

It was a hot day on the beach in Portugal. After searching for a shady spot to paint, I found one in the shadow of a large boat and completed this painting from there. I started the painting with a blue value sketch, knowing the shadows would change rapidly. Here, the sun was in front of me, creating the backlit painting.

After the blue had dried, I applied warm colors of Quinacridone Gold, Cadmium Orange, Scarlet Lake and Permanent Rose. I created the deep value of the water by applying several layers.

masking in layers

These beautiful flower pots were sitting outside an artist's studio, and I loved the way the light danced on the rich blue glaze. To make the pots the focus of the painting, I made the flowers larger in my sketch so they formed a nice frame around the pots. To add some depth and interest, I used blue's color harmonies in the leaves and flowers.

Retaining the light and whites, particularly in the pots, makes the glaze seem to sparkle. Plan for these areas in your sketch, and remember that you can always touch up areas toward the end of the process if necessary.

materials list

PIGMENTS

Antwerp Blue, Cadmium Orange, Cerulean Blue, Cobalt Blue, Cobalt Violet, Indigo, Permanent Magenta, Permanent Rose, Quinacridone Gold, Scarlet Lake, Winsor Yellow

SURFACE

140-lb. (300gsm) cold-pressed watercolor paper

BRUSHES

2-inch (51mm) hake, no. 4 rigger, no. 16 or 18 round

OTHER

Eraser, masking fluid, paper towels, pencil, rubber cement pickup, ruler, salt, spray bottle filled with water, toothbrush

Reference Photos
I took several reference photos that day to capture the nuances of the light and color in the pots.

Thumbnail Sketch
I took some artistic liberties and moved the pots around to make a more pleasing composition. Thumbnail sketches are a great way to work out ideas like this so you have a firm idea of what your composition will look like.

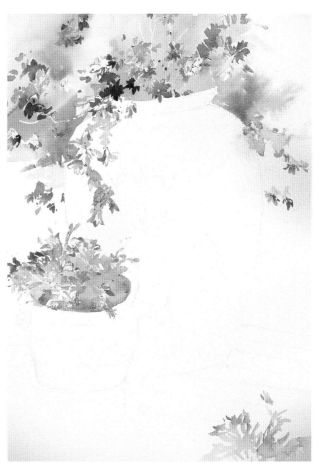

1 Sketch the Composition and Establish the Dark Flowers

Lightly draw your composition on watercolor paper with a pencil, using a grid if you wish. Carefully sketch the reflections on the pot. Closely examine the reference photos to determine the location of the white and light areas.

With a no. 16 or 18 round, apply Cobalt Blue, Cobalt Violet and Indigo to the dark flowers and the shadow areas in the foliage. Let this dry.

2 Apply Masking Fluid and Build the Foliage

Use the no. 4 rigger to apply masking fluid to the flowers and to the tops and sides of the pots. Let the masking fluid dry completely.

Mist the flower area with your spray bottle, then use a no. 16 or 18 round to drop in Cadmium Orange, Quinacridone Gold and Winsor Yellow next to each other. Spatter a bit of Scarlet Lake along the left side to create a light orange. Let this dry.

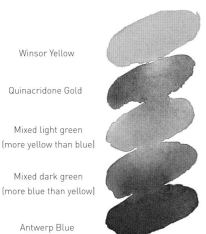

Winsor Yellow

Quinacridone Gold

Mixed light green
(more yellow than blue)

Mixed dark green
(more blue than yellow)

Antwerp Blue

Color Harmonies of the Foliage
To create the green leaves, first apply a yellow underpainting. As you add blue, you'll create vibrant greens that will harmonize with the yellows and blues.

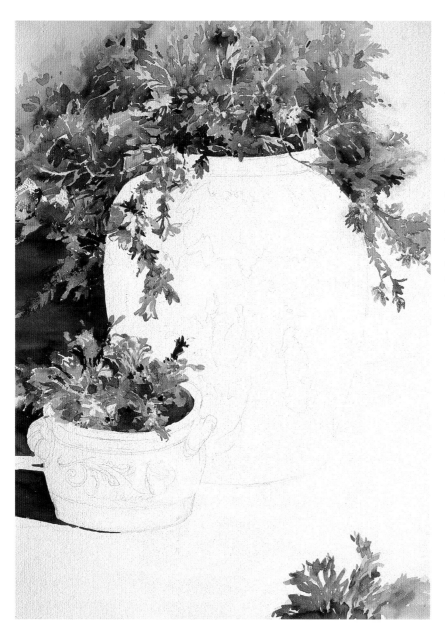

3 Establish the Background and Create Greens

Mask some leaf shapes with a no. 4 rigger to create the lightest yellow values in the leaves.

Wet the whole upper area with the 2-inch (51mm) hake and, using a no. 16 or 18 round, apply Cobalt Blue on the right and upper areas of the background and Antwerp Blue in the darkest areas on the left hand side. Let these two blues mingle and create the soft edges. The blues will also create greens when applied over the unmasked yellows. Apply some Cadmium Orange over the Cobalt Blue to create the brown of the soil.

Detail of Leaf and Flower Shapes
As you work, connect the flowers and leaves, remembering to overlap these shapes on top of the pots.

4 Paint the Pots

Since the leaves and flowers are masked, focus on painting the two pots.

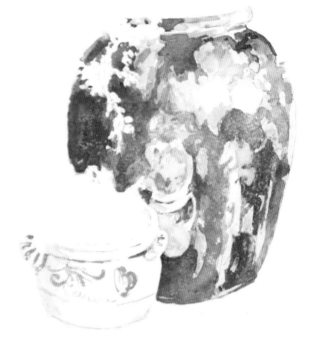

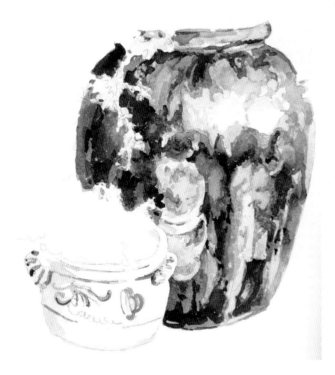

1 Apply a light shade of Cerulean Blue next to the lightest reflections on the large pot with a no. 16 or 18 round, saving the whites where the reflection is the lightest. Repeat this process on the design of the small pot. Remember to create its reflection on the larger pot.

2 Apply a very light shade of Cobalt Blue to indicate shadows on the small white pot, then echo this on the reflection in the larger pot. Apply a darker shade of Cobalt Blue to the darker areas of the large pot. Let this dry completely.

Dip a toothbrush in masking fluid, then run your thumb over the bristles so the masking fluid lands on the larger pot. Spatter more masking fluid using the no 4 rigger. Let this dry, then darken some areas of the larger pot with another layer of Cobalt Blue. While wet, sprinkle some salt over the Cobalt Blue.

3 Apply a juicy Antwerp Blue to the darkest areas of the large pot. Use a small amount of Antwerp Blue in the design of the white pot and in its reflection on the large pot. Once the Antwerp Blue is dry, apply Permanent Magenta on the darkest areas and Permanent Rose on the lower areas of the blue pot. This will result in a shiny glazed look.

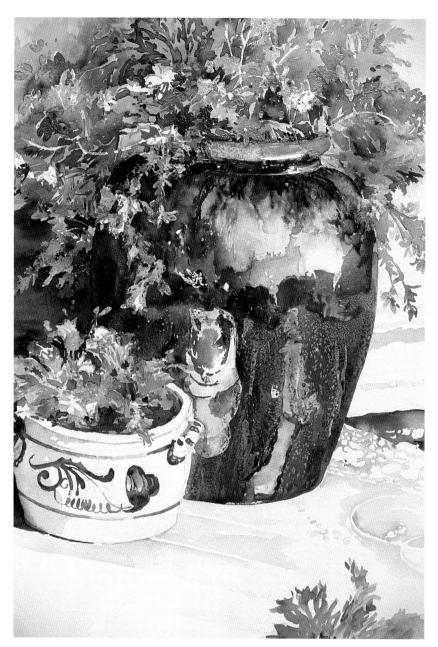

5 Refine the Foliage and Establish the Foreground

Mist the flowers and leaves in the pots with the spray bottle. Apply Cobalt Blue and Antwerp Blue to create another layer of greenery. As the dark colors emerge behind the light color harmonies of the leaves and flowers, a whole new dimension is revealed. Let this dry, then remove the masking fluid with the rubber cement pickup. Add some Quinacridone Gold in the large blue pot to suggest the reflection of the floliage.

Mask around the edge of the pots and the flower foliage spilling over the pots. Suggest the shadows on the ground with diluted Cobalt Blue. Let this dry. Use Indigo for the darkest spots.

Quinacridone Gold

Antwerp Blue

Permanent Magenta

Color Harmonies of the Pots and Flowers
Since the pot is blue, using its analogous color harmonies of green and violet will really make the composition stand out.

6 Add the Final Touches

Mix Scarlet Lake and Cobalt Blue to create a warm gray. Use this mixture to suggest the midground pebbles. Continue breaking up the deck areas by painting around the light shapes. Use Cadmium Orange in a few light areas to create interest. For darker shadows, apply another layer of the Scarlet Lake and Cobalt Blue mixture. Remove the masking fluid with the rubber cement pickup to reveal the beautiful color.

MIDNIGHT BLUE - 30" × 22" (76cm × 56 cm)

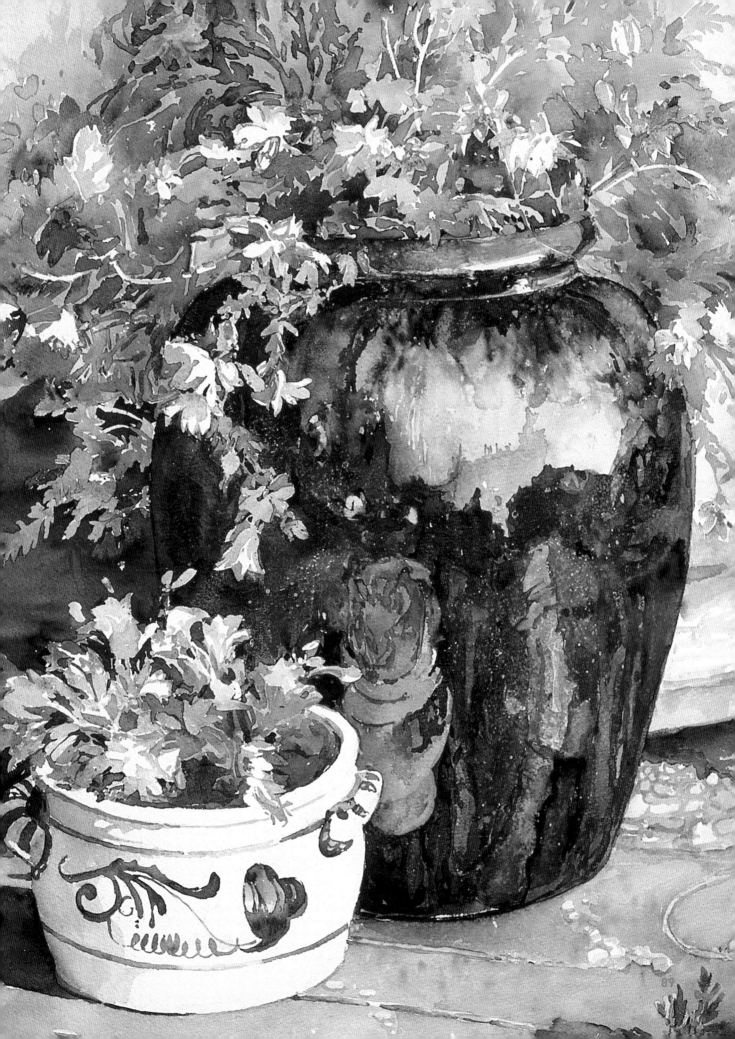

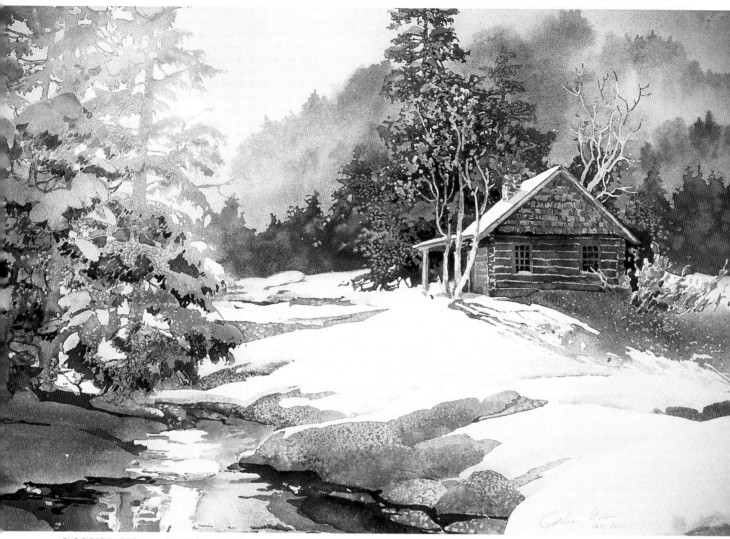

THE FIRST SNOWFALL - 22" × 30" (56cm × 76cm)

creating
dynamic paintings

Some of the most dynamic paintings might be of scenes closest to us. After the first snowfall I trotted through the snow to photograph our guest cabin as the sun was setting. Artistic liberties brought the water closer to the cabin and gave the hill more drama in the distance. The white subject gave me liberty to use color harmonies throughout the painting.

The cool shadows on the snow are blue with the harmonies of violets in the shadows and a golden glow created by the sun with the use of Quinacridone Gold. The pure colors were applied directly to the paper and allowed to mix as the wet pigments ran into one another. Note how the complementary color of orange sets off the painting.

WILD IRIS – 22" × 30" (56cm × 76cm)

texture adds interest

A painting with many visual layers is a challenge to paint but it is interesting to look at. Texture is one of my favorite ways to create an engaging scene for viewers. The amount of texture you include in your composition can help lead the viewer's eyes through the painting to the center of interest.

Texture Tips

- **Use texture to describe a surface.** It's not enough to simply paint a wooden bench brown. Adding the appearance of wood grain lets the viewer know what the bench is made of.

- **The more important the area, the more texture it should have.** The center of interest should have the most texture, as the viewer's eyes are naturally attracted to textural details.

- **Minimize the texture in the background and unimportant areas.** Your goal is to merely suggest details here. Too much texture and the painting gets busy and confusing. Sometimes less really is more.

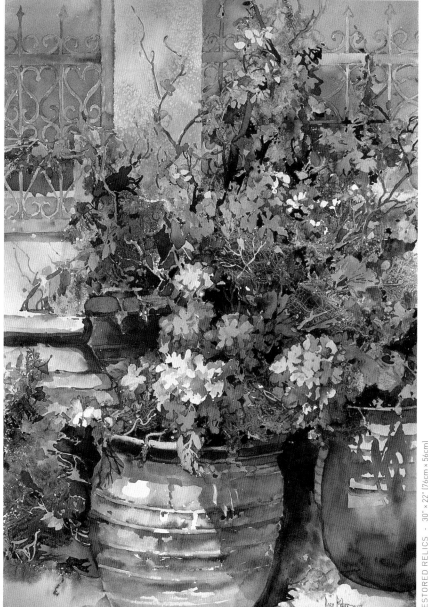

RESTORED RELICS · 30" × 22" (76cm × 56cm)

Values and Texture Create a Strong Interest Area
These lovely geraniums gave new life to the old handmade pots. Being placed against the interesting wall gave them drama. Consequently the foremost pot of flowers has more textural elements than the other objects in the piece.

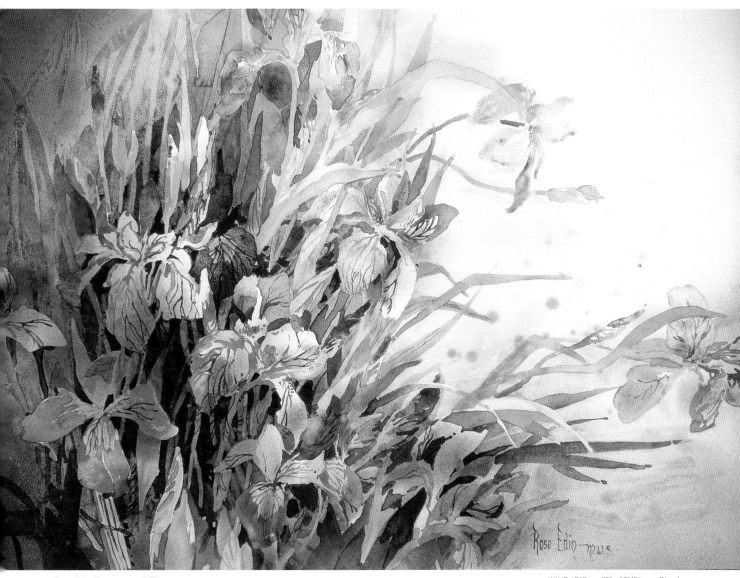

Detail in Foreground Flowers
Even the iris blooms and leaves in the center of interest have minimal detail—just a few lines
here and there to suggest texture and draw the viewer's eyes to this area.

WILD IRIS – 22" × 30" (56cm × 76cm)

designing with light and shadow

In each painting you create, you are ultimately painting light. Changes in color, value and texture are simply ways of mimicking the illusion of light. Light brings the objects in your composition to life through the interaction of light and shadow. In fact, the best way to paint light is to paint the shadows it creates.

Tips for Painting Light and Shadow

- **Light and shadow have color.** These colors are affected by the changing position of the sun and by the seasons, but, in general, the sunnier the scene, the warmer the colors you should use.

- **Light and shadows are affected by the atmosphere.** When the air is filled with moisture, as on a rainy or foggy day, the light will be dimmed, making everything appear muted.

- **Be consistent.** Make sure the light falls consistently on the items in your painting. However, don't be too tied to your reference photograph or the scene in front of you. Use light and shadows as necessary to lead the viewer's eyes comfortably through the composition.

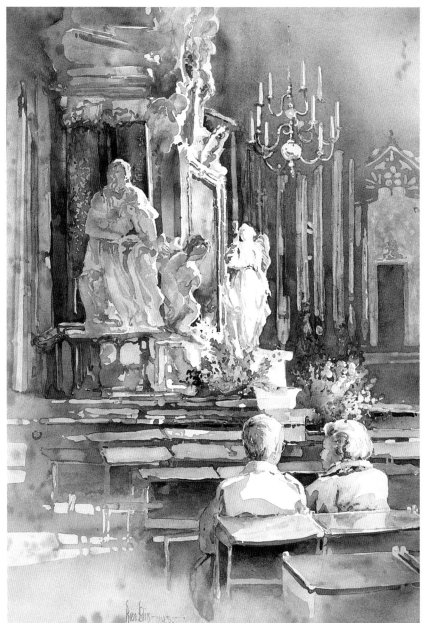

ORGAN MUSIC – 30" × 22" (76cm × 56cm)

Darkest Darks Behind the Lightest Lights
As we entered the beautiful cathedral in Vienna, the entire atmosphere was filled with the beauty of the setting as well as the sound of wonderful organ music. The light was streaming through the clerestory windows, hitting the altar. The figures glowed with the light of warm colors as they were illuminated by the strongest light source—the sun.

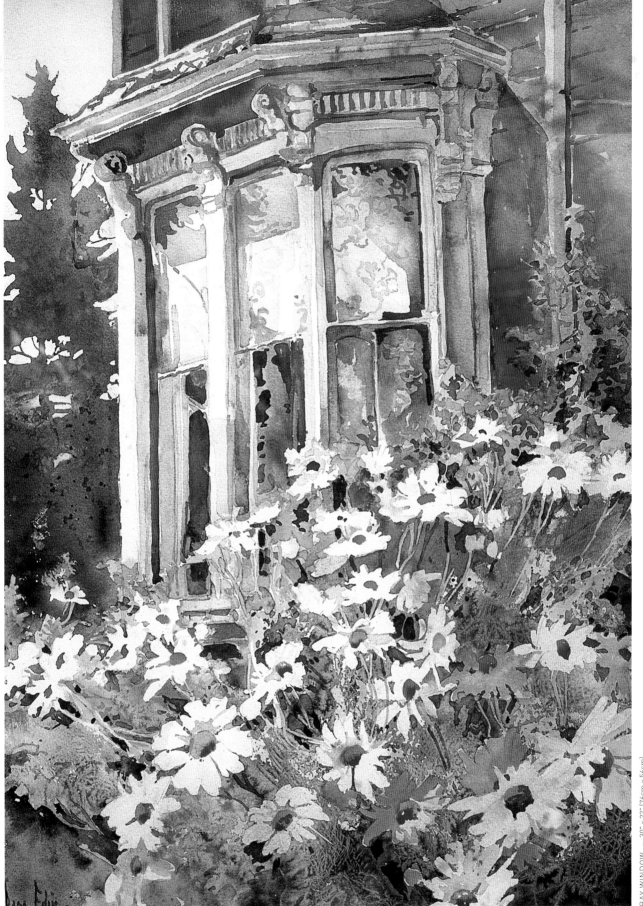

BAY WINDOW – 30" × 22" (76cm × 56cm)

Bright Sunlight

Outdoor subjects have a strong source of light if the reference photographs are taken in the sunlight. When the sun is shining, the most brilliant color can appear as white. Consider the source of light even if the subjects are from photographs taken on a cloudy day.

bringing out the center of interest

It was a hot summer day in Door County, Wisconsin, when I noticed a lady walking briskly with her baskets. Her red and white dress captured my attention as well as the gesture of her movements. This dress, with its pure white against the vivid orange and reds, would be my center of interest. The detail on the dress would tie all the other elements together.

materials list

PIGMENTS
Antwerp Blue, Cadmium Orange, Cobalt Blue, Permanent Magenta, Quinacridone Gold, Scarlet Lake, Winsor Yellow

SURFACE
140-lb. (300gsm) cold-pressed watercolor paper

BRUSHES
No. 16 or 18 round

OTHER
Eraser, pencil, ruler

Thumbnail Sketch
Work out your composition with a quick thumbnail sketch. I'm taking a bit of a risk here with this composition. The subject is close to the middle of the paper, but I believe the figure's slight diagonal movement along with the placement of the baskets and the counter-diagonal movement of the daisies will mitigate this.

1 Sketch the Composition
Use a pencil to lightly sketch the subject on the watercolor paper; use a grid if necessary. Once you're satisfied with the drawing, remove any grid lines or stray marks with an eraser.

2 Add the Shadows

Using a no. 16 or 18 round, apply a light value of Cobalt Blue to the shadows on the woman, the background and the baskets. Add another layer of Cobalt Blue to the darker shadows. Remember to save the white of the paper for the lightest areas. Let this dry.

3 Add Warm Tones

Using the no. 16 or 18 round, apply Quinacridone Gold to establish the second lightest areas, including the woman's hair, the portions of her dress you want to come forward and sections of the basket with daisies. Clean the brush, then apply Cadmium Orange to the slightly darker areas, including the daisy centers, the bottom of her dress and the basket she's holding against her thigh. Let this dry.

fixing underpainting mistakes

Cobalt Blue is easily wiped off if you make a mistake. This is because Cobalt Blue is a non-staining pigment, which means the pigment lies on top of the paper and doesn't soak deeply into the paper's fibers.

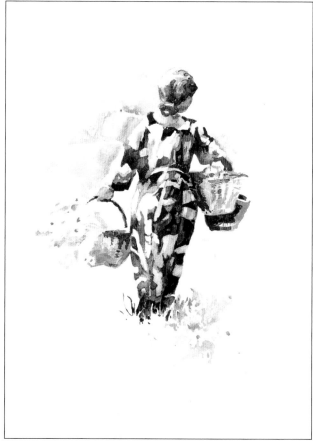

4 Add Warmth to the Figure

With the no. 16 or 18 round, add Winsor Yellow and Cadmium Orange next to the pure whites of the woman's hair, baskets and garment to lend a sunny glow to the figure. Add a little Winsor Yellow to the background tree and foreground grass and flower area. Let this dry.

5 Refine the Center of Interest

With the no. 16 or 18 round, apply Scarlet Lake next to the Cadmium Orange and over the Cobalt Blue shadows in the woman's dress and on her face. Let this dry, then add touches of Permanent Magenta to darken any areas necessary. Your goal is to suggest the woman's form and her movement as she walks toward the background.

Apply Quinacridone Gold and Permanent Magenta to the baskets, further defining their shape. (You can paint the lower baskets the same way you painted the baskets she's carrying.) Let this dry completely.

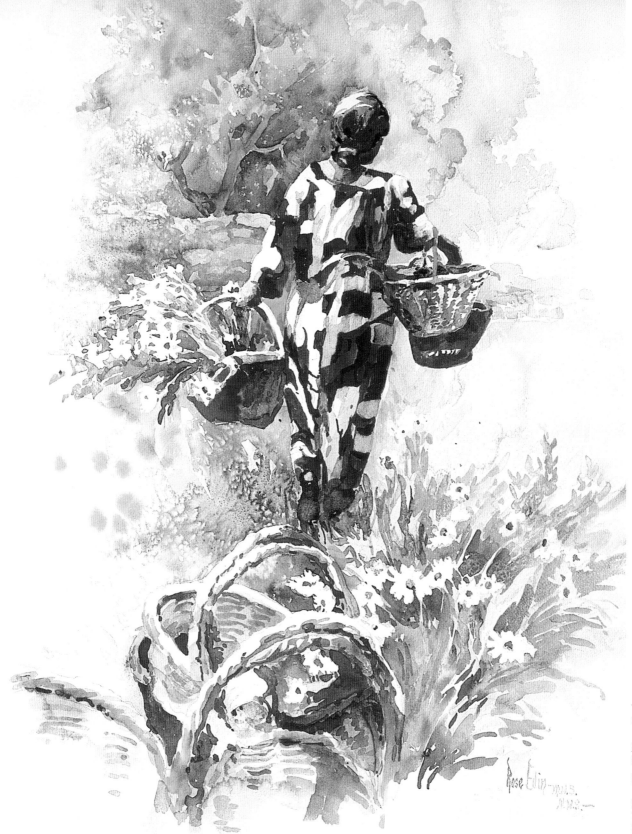

Keep the Background a Light Value for Contrast

From here you can build the foreground and background areas using the same colors as your center of interest. The white on the figure's dress, daisies and highlights on the baskets will stand out with a light background. I wet the background and placed diluted Winsor Yellow, Quinacridone Gold and Antwerp Blue next to each other so they would mingle on the surface. You do this by either painting around around the figure, baskets and daisies or by using masking fluid.

build layers for luminous color

Kalvåg, Norway, is a beautiful place, and a paradise for artists and photographers. I have been lucky to paint this location several times.

As I evaluated this particular scene, I decided to include most of the elements in my reference photo. The atmosphere of the boat, buildings, rocks and water may present a challenge, but why not go for it? Using a grid will help you accurately portray perspective in this complex scene.

materials list

PIGMENTS
Antwerp Blue, Cadmium Orange, Cobalt Blue, Permanent Magenta, Scarlet Lake, Winsor Yellow

SURFACE
140-lb. (300gsm) cold-pressed watercolor paper

BRUSHES
2-inch (51mm) hake, no. 4 rigger, no. 16 or 18 round

OTHER
Eraser, masking fluid, painting knife, pencil, ruler, spray bottle filled with clean water

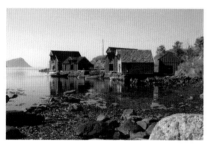

Reference Photo
Spend some time looking at your reference photo and decide on your interest area and how to tie the elements together. The white boats moored next to the red building create a nice contrast perfect for a center of interest.

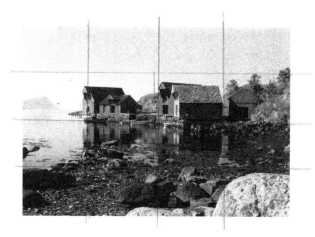

1 Create a Grid on the Reference Photo
Photocopy (and enlarge, if needed) the photograph. Divide the photocopy into sixteen sections with the same proportions as the paper.

2 Sketch the Subject on Your Watercolor Paper
Pencil in the grid on your surface to help you sketch the composition on your watercolor paper. Create more detail on the boats, which will be the interest area. Erase the grid lines after you finish drawing.

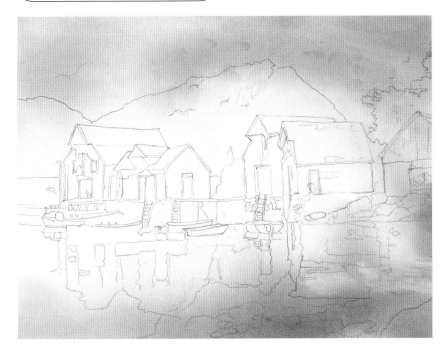

3 Create a Vibrant Basecoat

The basecoat will form the basis of the sky and water. Wet the entire paper with clean water using the 2-inch (51mm) hake. Load the no. 16 or 18 round with juicy Winsor Yellow and apply a layer above and below the center of interest and a bit on the right side. While this is wet, clean your brush and load it with a diluted Scarlet Lake and apply it next to the Winsor Yellow. Clean your brush again and load it with Cobalt Blue and place this next to the Scarlet Lake, going all the way to the upper and lower edge of the paper. Spray lightly any area where the paint appears to lose its shine, then tip the paper so the colors will run together.

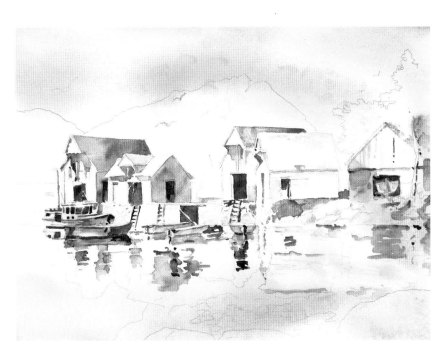

4 Develop the Shadows

Use the no. 4 rigger to apply masking fluid over the boats and their reflections. Use the edge of your painting knife to apply mask to the mast and the seagulls. Mask the ladders, the top of the rocky edge of the retaining wall and the white trim of the buildings. Let this dry.

Create the dramatic shapes of the buildings and their reflections in the water with Cobalt Blue and a no. 16 or 18 round. Note how the creation of these blue shapes ties the painting together. Apply Cobalt Blue to the shadowed side of the rocks and their reflections. For the reflected shapes, create a slightly wavy edge to suggest the water's movement. Notice the mountains are not reflected in the water because they are too far away.

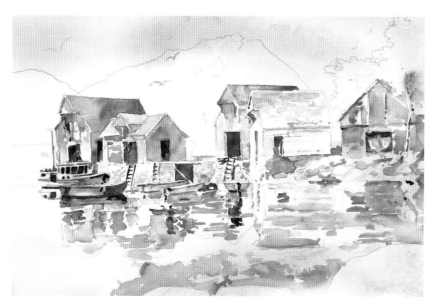

5 Establish the Buildings' Basecoat

Apply diluted Cadmium Orange in the sunlit areas of the buildings, retaining wall and their reflections, saving the whites for the brightest lights. Apply another layer of Cadmium Orange for the darker areas. Remember to suggest the movement of the water by creating slightly wavy and broken lines in the reflection area of the houses. Create the basecoat of the midground rocks with Cadmium Orange, varying the intensity of color to create lights and shadows.

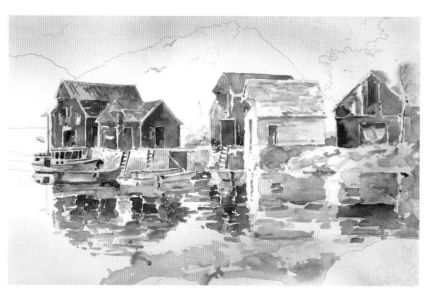

6 Continue Developing the Buildings

With the no. 16 or 18 round, place Scarlet Lake next to the orange areas and occasionally apply the Scarlet Lake over the Cadmium Orange to create a brilliant red on the buildings. Keep the colors thin for the center building. Continue the red into the water to develop the reflections of the houses. The slightly wavy edge of the shape needs to be broken up occasionally in a horizontal movement of the wave, so avoid filling in the reflection completely. Daub some Scarlet Lake into the retaining wall.

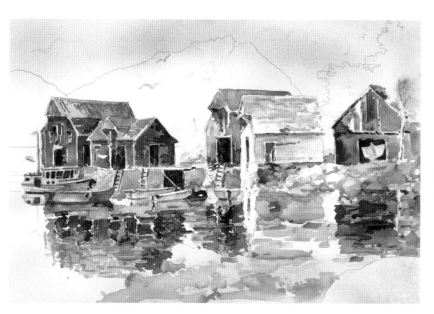

7 Darken the Buildings' Shadows

Use the no. 16 or 18 round to apply Permanent Magenta over some of the blue shadows including the right side of the buildings or where one building casts a shadow on another. For the darkest darks in the windows and doorways of the buildings and their reflections, apply a mixture of Permanent Magenta and Antwerp Blue.

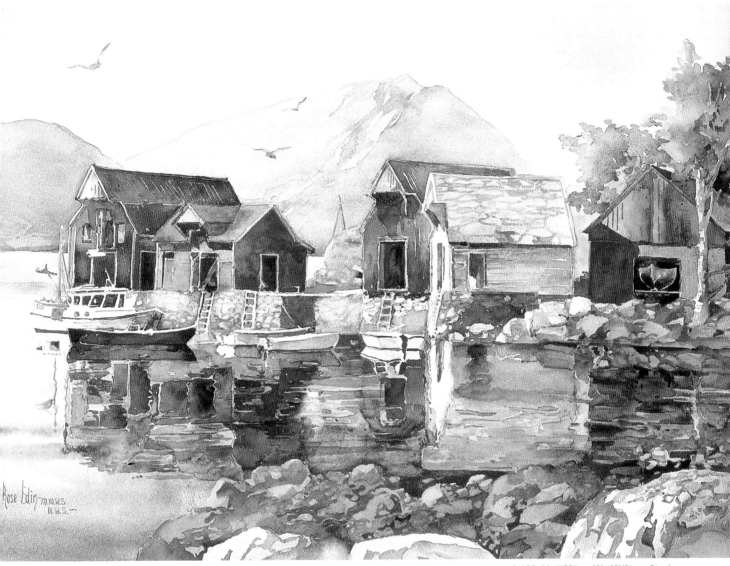

Repeat the Colors in the Surroundings

Use the colors of the buildings to refine their surroundings, including the foreground rocks, the water, mountains and trees. Keeping the palette simple helps you maintain color harmony.

painting water

Reflections are often darker than the object they're reflecting. When the wind hits the water, it moves and the ripples reflect a refracted light. This broken light is actually the color of the sky. As the reflections come closer to you, the movement of the water becomes larger.

suggesting light with color

These children were exploring a path that led to a beautiful waterfall in a park in South Africa. The sun was peeking through the trees, dancing on the children and the ground.

The warm tones on the figures against the cool colors of the foliage accentuate the center of interest. All the greens, blues and violets of the forest will be grayed by layering the entire work with an underpainting, which will be explained as you move along with this demonstration.

This painting illustrates how you can use the application of masking fluid numerous times and in different stages in a painting to achieve some very interesting and seemingly complex results.

materials list

PIGMENTS

Antwerp Blue, Cadmium Orange, Cerulean Blue, Cobalt Blue, Cobalt Green, Permanent Magenta, Permanent Rose, Scarlet Lake, Winsor Yellow

SURFACE

140-lb. (300gsm) cold-pressed watercolor paper

BRUSHES

2-inch (51mm) hake, no. 4 rigger, no. 16 or 18 round

OTHER

Eraser, masking fluid, pencil, rubber cement pickup, spray bottle filled with clean water

1 Sketch the Subject and Mask the Figures

Draw the composition of the painting, making sure to leave spaces in the trees for the sun to peek through. Apply a layer of masking fluid over the figures with the no. 4 rigger. Let this dry completely.

make masking fluid easier to see

If you use clear masking fluid, you can add a small amount of watercolor pigment to tint the masking fluid before using it.

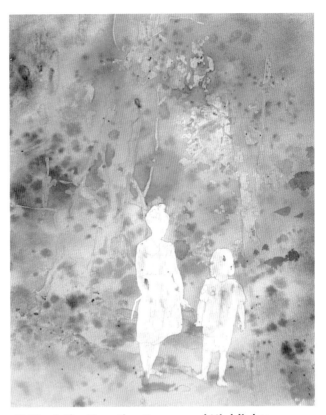

2 Create a Vibrant Underpainting

Wet the entire paper with clean water using the 2-inch (51mm) hake. Load the no. 16 or 18 round with juicy Winsor Yellow, and apply a layer of this in the area where the sun will be shining through the trees. While this is wet, clean your brush and load it with Scarlet Lake, and apply this around the Winsor Yellow. Clean your brush again, load it with Cobalt Blue, and apply it around the Scarlet Lake. Tip the paper so the colors run together; misting your paper with the spray bottle if the area starts to dry. Spatter some spots of the Winsor Yellow using your no. 16 or 18 round. Clean your brush, then spatter some Scarlet Lake, then Cobalt Blue onto your paper.

3 Mask the Negative Spaces and Highlights

With a no. 16 or 18 round, spatter Cadmium Orange and Cobalt Green over the paper, cleaning the brush before picking up another color. With the no. 4 rigger, mask the areas of the sky in and around the trees. (You can actually sketch these areas out with a pencil before applying the mask, or simply carve out these areas with your rigger loaded with masking fluid; just make the shapes irregular to suggest the edges of the foliage and branches.) Mask the shapes of the flowers along the ground and apply thin, broken areas of masking fluid to the tree trunks and along the ground to suggest sunlight hitting these areas. Remember, you are saving the areas you want to appear lighter or where you want to save brilliant color that will contrast the dark layers you'll create.

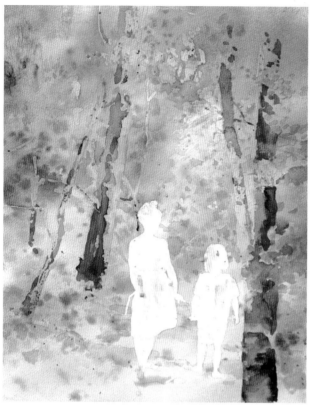
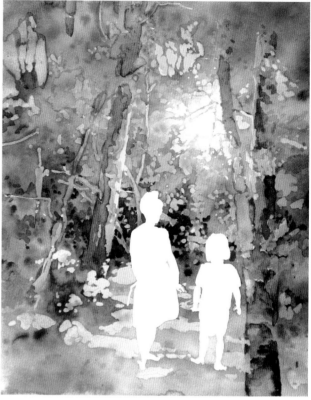

4 Darken the Background

Rewet your paper with the 2-inch (51mm) hake, then apply another layer of Winsor Yellow next to the sun spot with the no. 16 or 18 round. Next to this, apply Scarlet Lake and then Cobalt Blue, working from the center outward and cleaning the brush before picking up a new color. Tip the paper in all directions so the colors run together.

While the paper is wet, apply a mixture of Scarlet Lake and Cobalt Blue onto the tree trunks. Don't worry if the color bleeds out from the trunks; this will create soft edges. Let this dry thoroughly.

While the surface is still wet, spatter more Winsor Yellow, Cadmium Orange and Cobalt Green all over the paper. Then spatter Cerulean Blue and a bit of Scarlet Lake where the foreground flowers will be. Remember to clean your brush before picking up a new color.

5 Continue Building the Background

With the no. 4 rigger, cover all of the tree trunks as well as some branches and leaves with masking fluid, using the masking fluid to carve out the shapes of the branches and leaves. Be especially attentive to the detail around the sun. Also mask the shapes where you want your foreground flowers. Let this dry completely.

Following the process in step 4, wet your paper with the 2-inch (51mm) hake, then apply Winsor Yellow around the sun area, followed by Cadmium Orange, Scarlet Lake, Permanent Magenta and Antwerp Blue, working outward toward the edges of the paper. Let the painting dry completely.

Remove the masking fluid from the entire painting so the children appear without any paint on them as well as several light areas to indicate the pattern of sunlight.

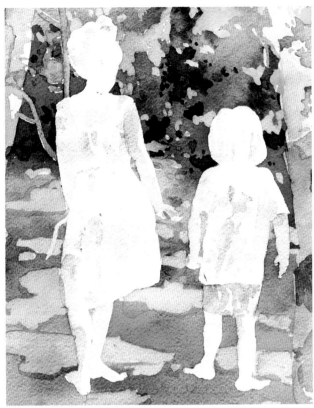

6 Establish the Shadow Areas on the Children

With a no. 16 or 18 round, apply Cobalt Blue to the shadow areas of the children. Save the whites on the areas of the strongest sunlight.

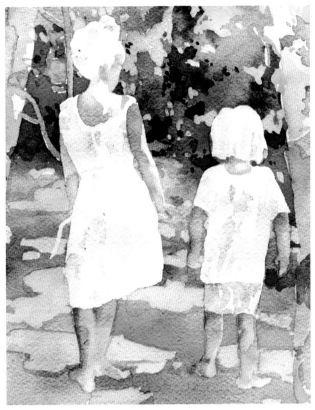

7 Create the Skin Tone

Create a warm skin tone with Scarlet Lake and Winsor Yellow, letting the colors mingle together on the paper. Use a no. 16 or 18 round to apply these pigments, saving the whites.

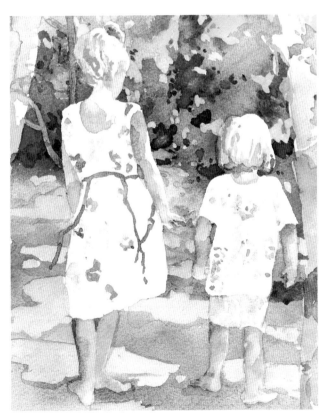

8 Paint the Details

Using a no. 16 or 18 round, drop in some Winsor Yellow and Cadmium Orange to suggest the children's hair. Use mostly Winsor Yellow in the little girl's hair.

Apply Cadmium Orange dots for the flower centers on the dress of the little girl's shirt. Apply Cadmium Orange and Scarlet Lake next to each other on the flowers and ribbon of the older girl's dress, and add Permanent Rose to areas you wish to darken.

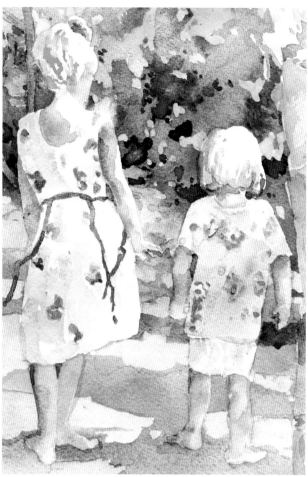

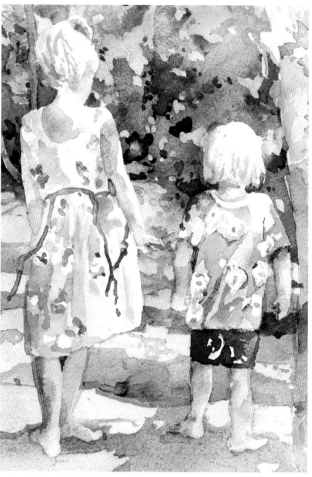

9 Paint the Girls' Clothing

Create the light green of the dress by applying Winsor Yellow next to the white of the paper, using the no. 16 or 18 round. Lightly add Cobalt Green around the flowers. Refine the deepest shadows with a layer of Antwerp Blue.

Darken the flowers of the little girl's shirt with Permanent Magenta and Cobalt Blue in the darkest areas and use Scarlet Lake and Cadmium Orange in the lightest areas. Adjust the girls' hair as necessary.

10 Enrich the Figures

If the figures were still a bit too light in contrast to the darker background, add additional layers of color in the darker areas of the figures to help them stand out more. Add a layer of Scarlet Lake over the children's skin, then place a little more Winsor Yellow over the blue areas of the older girl's dress. Darken the shadows on the green dress with Antwerp Blue, then paint Cobalt Blue around the flowers of the little girl's shirt. Add a light glaze of Permanent Rose over the blue in the shadow area. Paint the skirt with Cobalt Blue and Permanent Magenta in the very deepest shadows.

11 Add the Finishing Touches

Detail the entire painting by breaking up some of the color in the tree trunks. Paint the flowers with Scarlet Lake and Cobalt Blue. Refine the figures if needed.

THE SECRET GARDEN - 30" × 22" (76cm × 56cm)

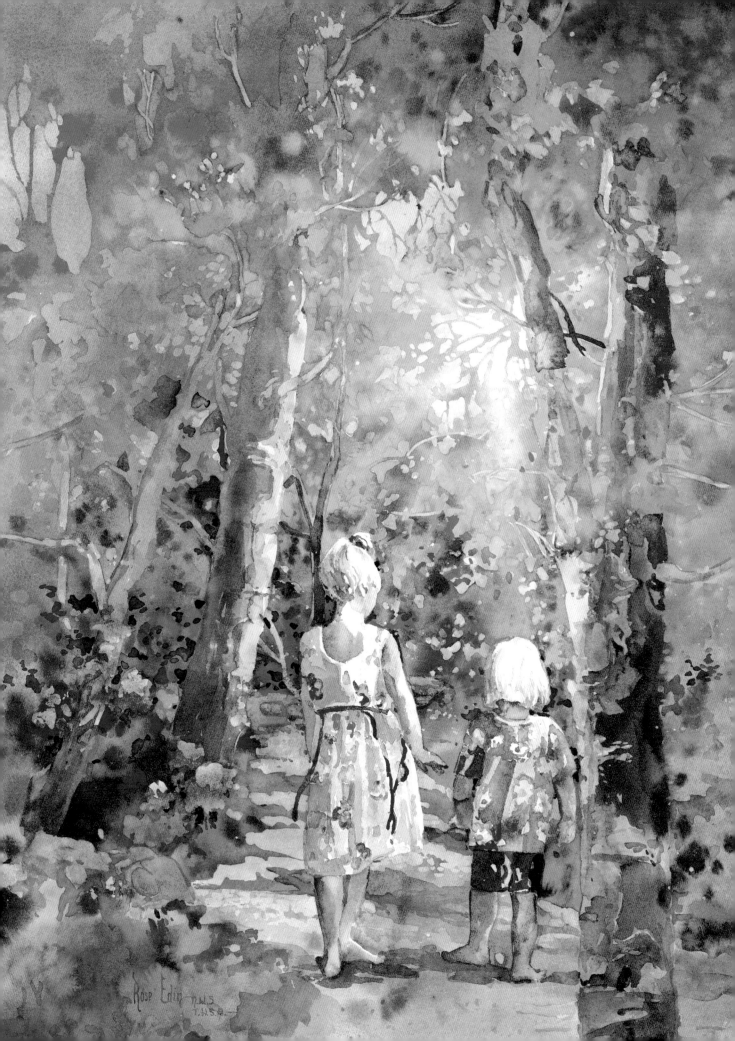

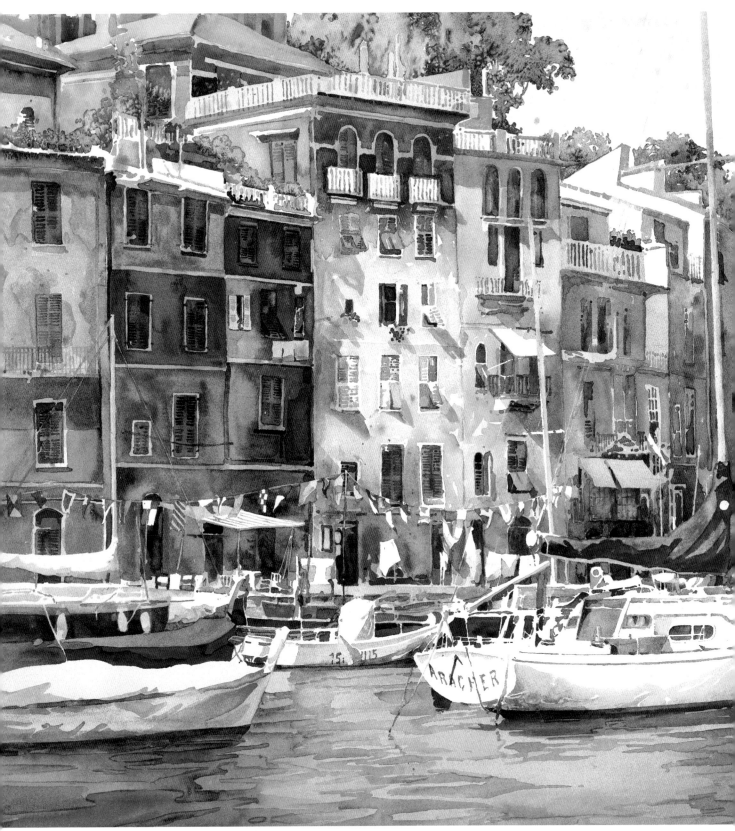

THE ITALIAN RIVERIERA · 30" × 40" (76cm × 102cm)

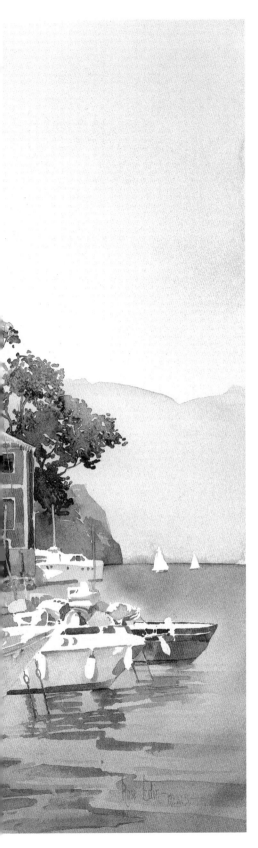

conclusion

Improving your painting abilities is a reflection of strong technique, but it's also a matter of developing creative ways of thinking. In this way, we are never finished learning. There is always more to discover as we polish our skills and expand our thinking.

I am sure you have noticed some overlapping of explanations and techniques. Each painting is a combination of many elements, and something repeated is easier learned, remembered and then applied. With this in mind, enjoy the gallery.

—Dee Jepsen

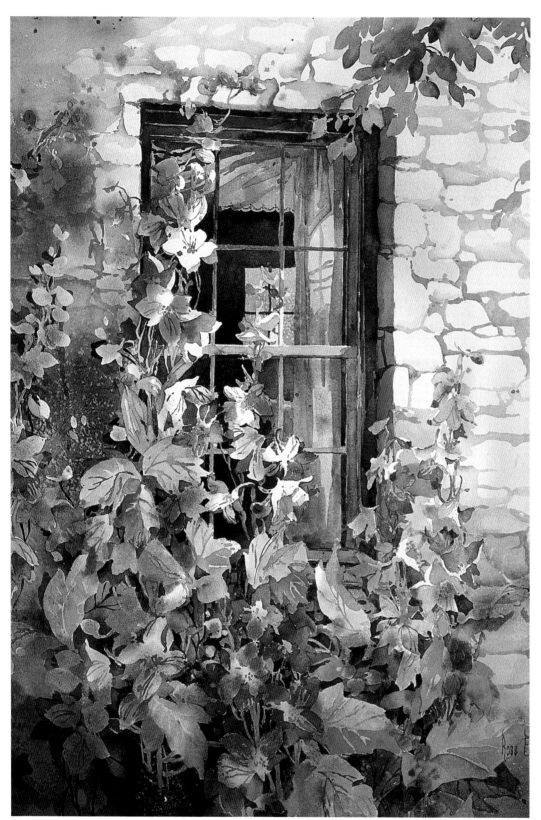

Layers of Interest
The beautiful blue delphiniums caught my eye. I painted them with the blue's analogous colors—light green and violet. I carefully left a little white where the sun hit. The leaves were painted next with light yellow and blue mingled together to form green. They were then masked before the window behind them was added. Note how the very darkest area in the painting is the shadow within the window and the other side of the building, creating layers of interest.

THE WINDOW—DOOR COUNTY · 30" × 22" (76cm × 56cm)

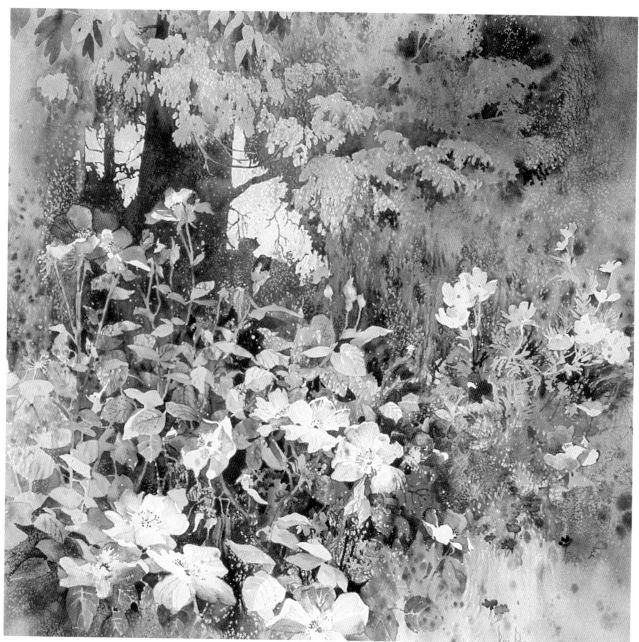

Experimenting With Salt

The inspiration for this large painting was a hugh bouquet of wild roses. After painting the roses and leaves as illustrated on p.20, I masked them. To make these flowers pop out, I applied very thick pigments next to each other on the wet paper. I then tipped the painting so the colors ran together. While the paper and paint were still wet, I applied salt and placed the painting on an angle so the salt would run. It was very exciting to see the results develop.

FOREST FLOWERS - 30" × 40" (76cm × 102cm)

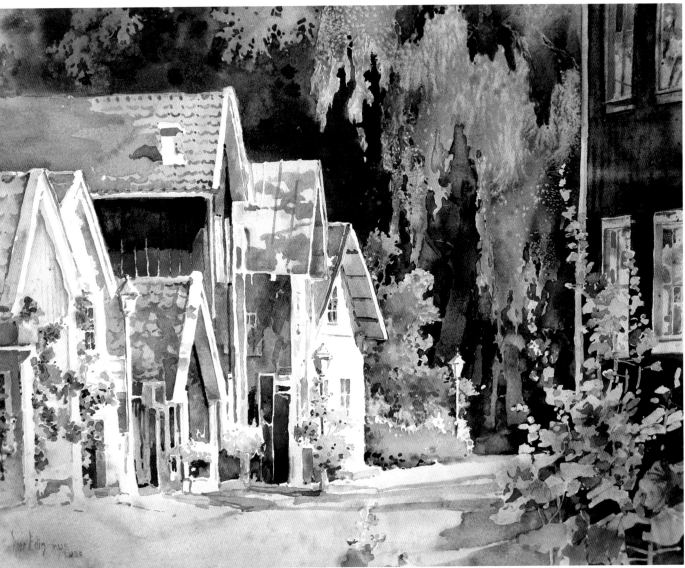

Creating the Illusion of Light

In Sweden the old original buildings are preserved as they are here in Kalmar. The sunlight was very intense. All of the buildings are linked together with the white of the paper. The subject really stands out because some of the buildings are strong red and others are yellow. The light greens on the willow tree are created with salt and letting it dry tilted on an angle. To make the buildings pop out the dark color harmonies of green are mingled in the background. The reds are mingled over the darker blue underpainting in the foreground building on the right.

GAMLA STAN—OLD TOWN - 22" × 30" (56cm × 76cm)

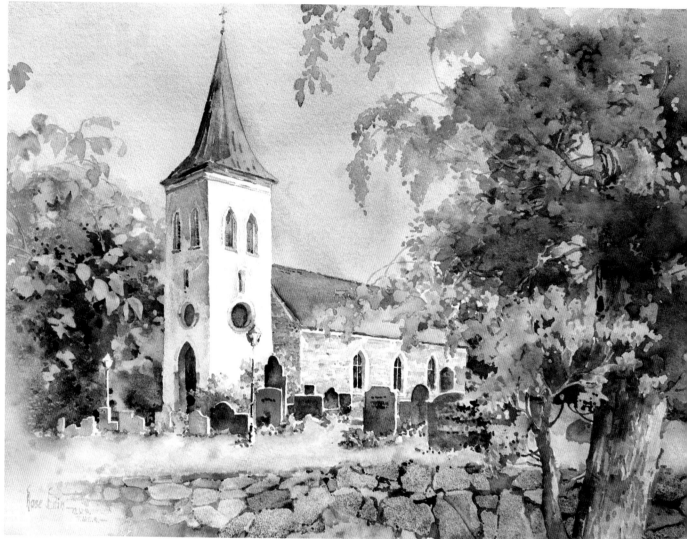

Linking Elements

This is the Källeryd church in Sweden where my father was confirmed and baptized. I have painted this subject several times. This time, I wanted to include several elements, such as the stone wall, trees, tombstones and, of course, the beautiful church. The church stands out because of the pure white of the paper, which is left unpainted. The dark tombstones below link the darker tree areas that do not include much detail. The middle value of the stone wall also helps repeat the long horizontal shape against the dynamic vertical shape of the white steeple.

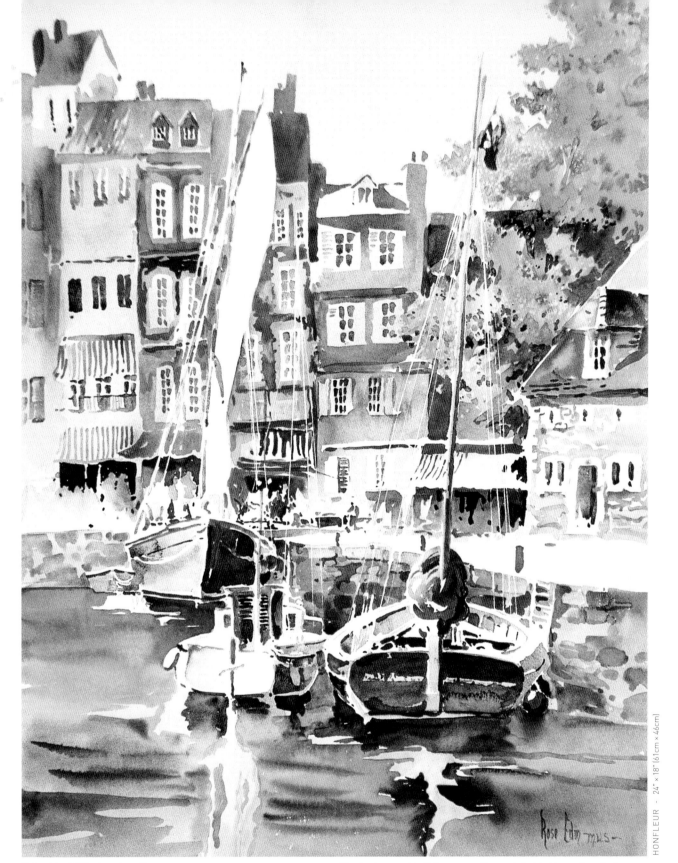

HONFLEUR – 24'' × 18'' (61cm × 46cm)

Using Liquid Mask on Location

After leading a painting group to France we decided to stay on for a few days. The harbor in Honfleur was stunning. For me it would be impossible to do the rigging on the boats without some help. Liquid mask and a painting knife were the answer I needed. I used the blade of the knife after dipping in the mask to create the fine lines.

The background buildings were then painted in blue values before applying the color around the windows. A horizontal movement in the composition was created by the light hitting the edge of the harbor. The vertical movement is created with the white sails and the masts.

116

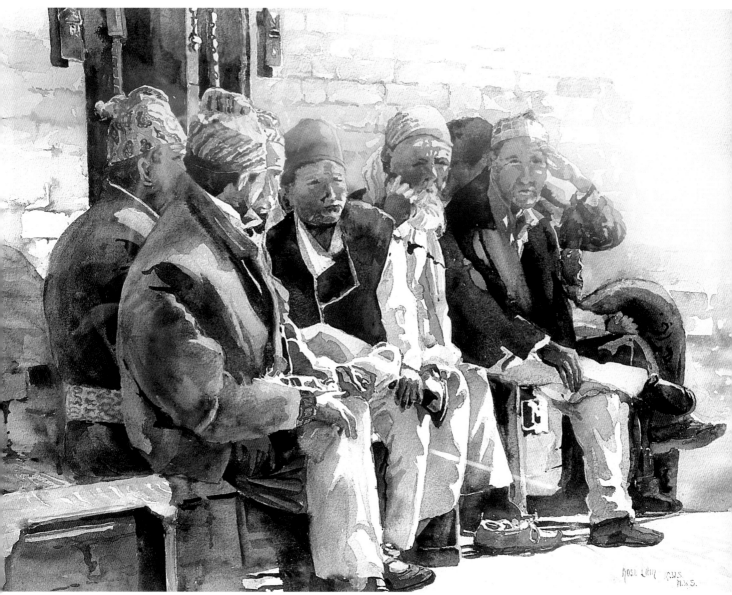

Using Dark Values in the Interest Area

We were brought back to reality when we encountered these men sitting together in the village square in a remote mountain town at the foot of the Himalayas in Nepal. The man in white was talking on a cell phone (which I eliminated in the painting). Their interesting green outfits were a challenge to paint. The vibrant dark values in this painting draw your attention to the center of interest, which is the man in white who is looking at us.

NEPALESE GENTRY – 22" × 30" (56cm × 76cm)

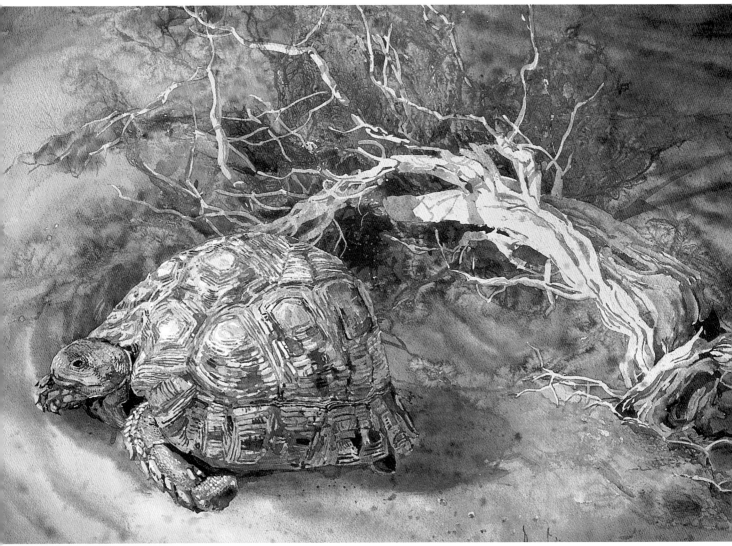

CAMOUFLAGE - 22" × 30" (56cm × 76cm)

Create Minute Detail

The African country of Botswana is full of surprises. This leopard turtle was hiding under a dead branch in the red sand. The challenge was to create some of the very lightest values in the turtle's shell while maintaining a warm color scheme. In order to achieve this, I used the most vibrant yellow, orange and red from my palette in the lightest areas next to the white of the paper. Each distinct shape on the shell of the turtle was carefully crafted. The darker values of gold and dark red were used in the lower shadowed areas to create the detail and the rounded shape of the shell.

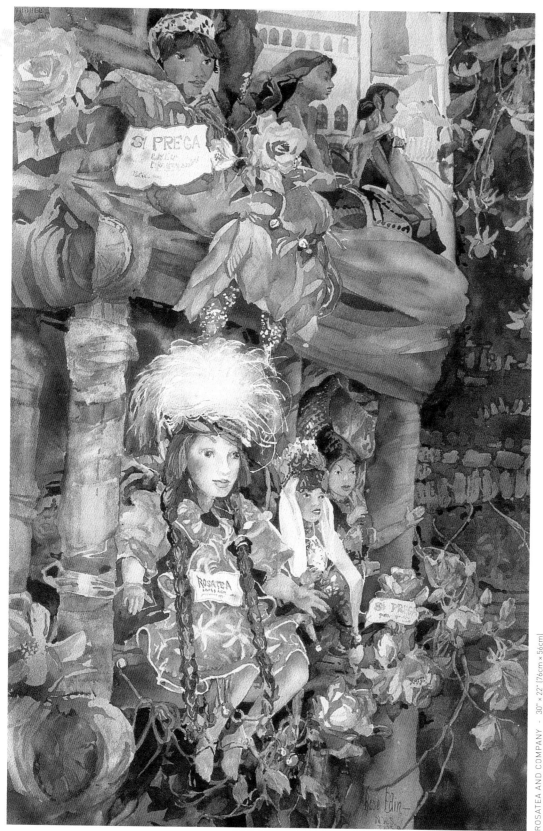

ROSATEA AND COMPANY – 30" × 22" (76cm × 56cm)

Connect With Shapes

While wandering down a little narrow street in a town in northern Italy, I came upon this wonderful shop window. This studio painting evolved from several photographs and a lot of artistic liberties. I used a palette knife dipped in masking fluid to create the fine lines of the headdress of the puppet, whose name was Rosatea, and on the glittering detail of the shoes on the upper figure.

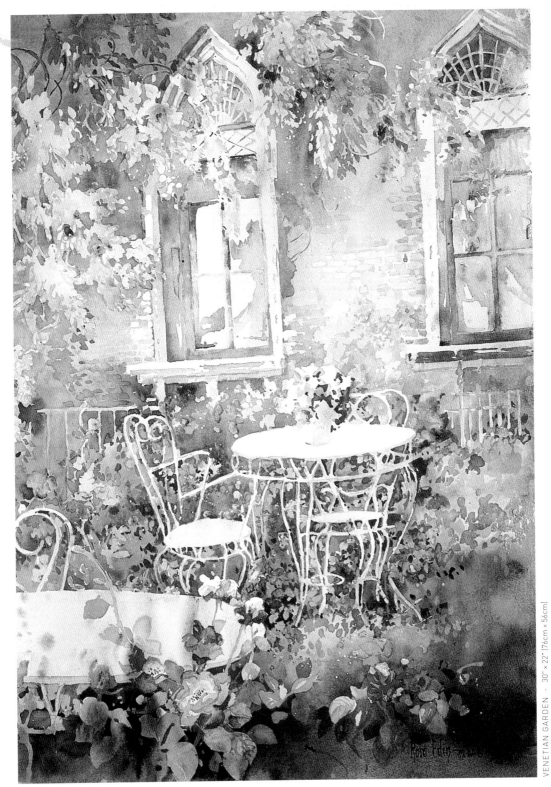

VENETIAN GARDEN – 30" × 22" (76cm × 56cm)

Paint Where You Are

Because it was raining very hard in Venice, Italy, rather than paint outside, I simply looked out my window and discovered the chairs and table in the garden.

You, as an artist, will find interesting subjects wherever you are. Look for these subjects and use artistic liberties in moving things around.

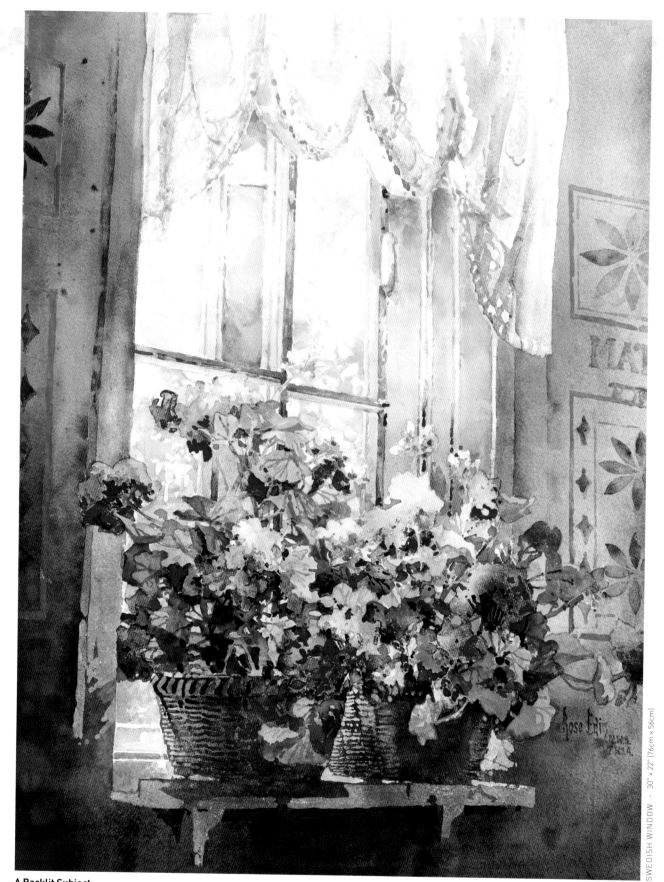

SWEDISH WINDOW – 30" × 22" (76cm × 56cm)

A Backlit Subject

After driving most of the day in the Swedish countryside, we were hungry for a cup of coffee and a snack. We found the perfect spot north of Uppsala. The geraniums had been nurtured all winter and were in brilliant bloom as the bright sunlight streamed through the window. The lightest area is the sunshine behind the flowers.

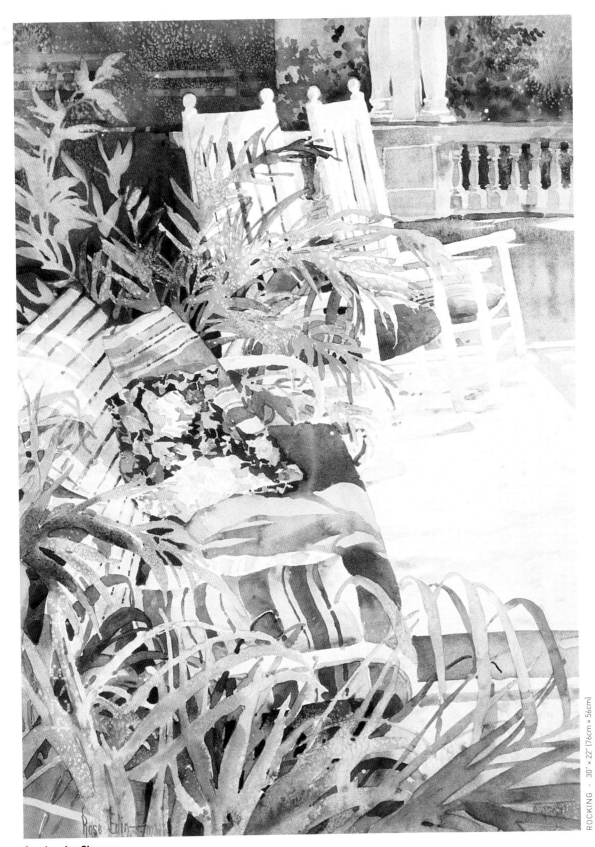

ROCKING · 30" × 22" (76cm × 56cm)

Overlapping Shapes

All the foliage around the chairs offered a big challenge. I used yellow, green and blue to create a harmonious color scheme among the plants. Once that dried, I masked the plants, then painted the darks behind the white shapes of the chairs. Lastly, I added a slight wash to the foreground to keep it in shadow.

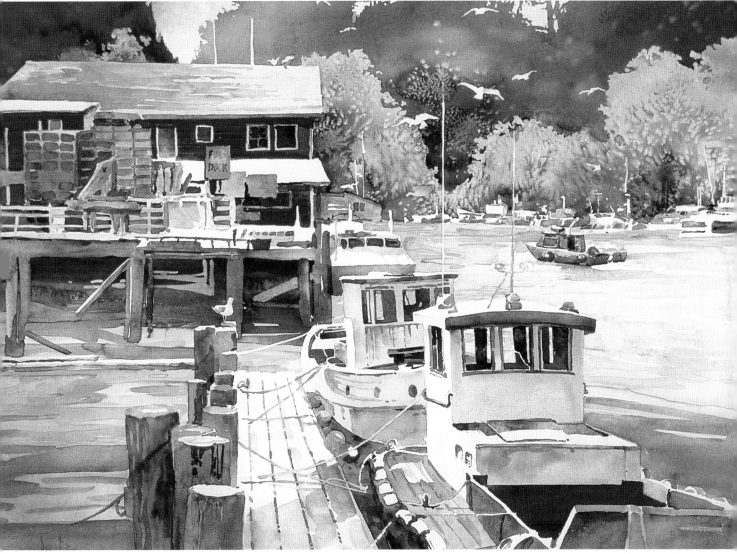

Repeating Shapes

This was an unexpected sight on the coast of Northern California. All the rectangular shapes led up to the interesting red fishing shack. The light shapes on the water, dock, sky and upper boats are just as important as the positive shapes of the elements in the painting. This will make a static composition dynamic as the white and light shapes connect all the elements.

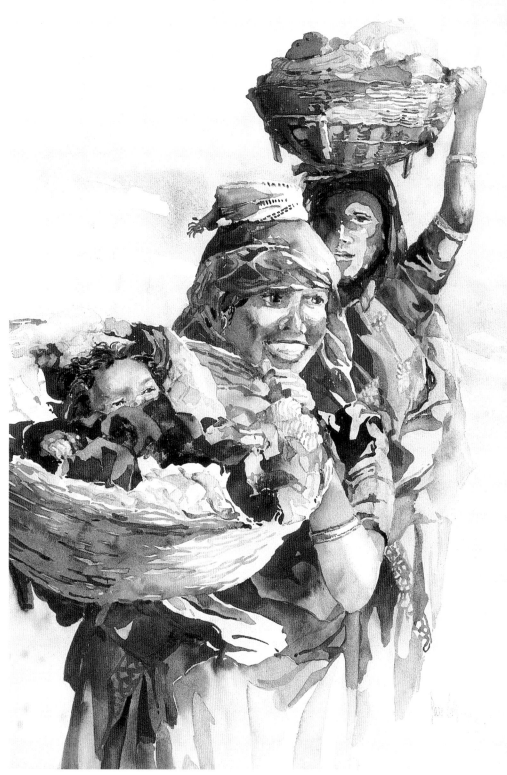

Brilliant Color Attracts Attention

These women were walking along a dusty road in Rajasthan, India. My husband asked this woman who was carrying her baby in the basket if he could photograph her. She was very happy to show off her adorable child. Several photographs were taken of this procession. The brilliant color harmonies of reds and oranges brightened up the dusty Indian landscape.

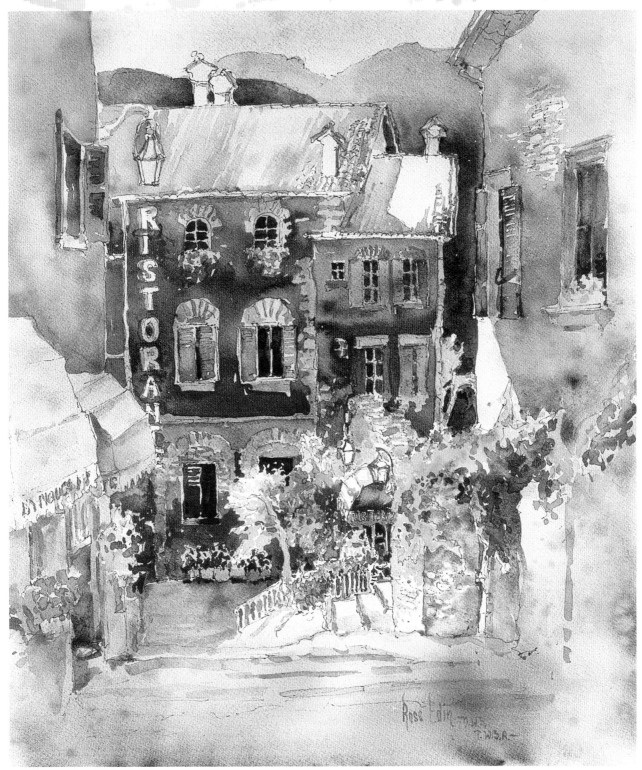

Establish Mood

It was a steep climb up to the hill town of Gubbio in northern Umbria. We found a perfect subject to paint where our entire group of artists could sit on the steps and look down on this delightful scene. The sun was hitting the lower part of the street, so I worked quickly to establish the blue shadows first, since shadows change very rapidly. I then put in an underpainting of yellow, red and blue and left the sunlit areas the white of the paper. Then colors were applied in layers to create the mood of this scene.

Index

Ideas. Instruction. Inspiration.